The College History Series

SAINT MARY'S COLLEGE

AMANDA DIVINE AND COLIN-ELIZABETH PIER

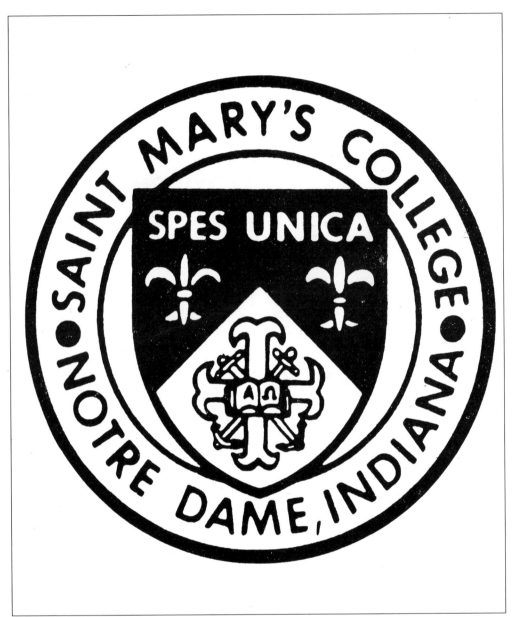

The seal of Saint Mary's College is a modified version of the seal of the Congregation of the Holy Cross. The motto, "Spes Unica," the cross, and the anchors are all common to both seals. The "alpha" and "omega" on the open book symbolize Christian education, while the two fleur de lys commemorate the French origins.

The College History Series

SAINT MARY'S COLLEGE

AMANDA DIVINE AND COLIN-ELIZABETH PIER

ARCADIA

Copyright © 2001 by Amanda Divine and Colin-Elizabeth Pier.
ISBN 0-7385-1852-2

Published by Arcadia Publishing,
an imprint of Tempus Publishing, Inc.
3047 N. Lincoln Ave., Suite 410
Chicago, IL 60657

Printed in Great Britain.

Library of Congress Catalog Card Number: 2001086232

For all general information contact Arcadia Publishing at:
Telephone 843-853-2070
Fax 843-853-0044
E-Mail sales@arcadiapublishing.com

For customer service and orders:
Toll-Free 1-888-313-2665

Visit us on the internet at http://www.arcadiapublishing.com

I love thee, Alma Mater, and thou art to me the same,
In the spring-time or the autumn,
when the woods are all aflame,
And the thought of thee, Saint Mary's, in
the swiftly passing years,
Fills my heart with happy memories, fills my eyes with grateful tears.

By Marie G. Kierstead, class of 1903. Taken from a November 1903 issue of *Chimes*.

CONTENTS

ACKNOWLEDGMENTS

A special debt of gratitude is reserved for John Kovach, of the Saint Mary's Archives, for his time, humor, creativity, and invaluable assistance on this project.

We would also like to thank the following individuals, organizations, and businesses who have assisted us in a variety of ways: Saint Mary's College, Sister Julie McGuire, C.S.C., the Archives of the Sisters of the Holy Cross, Scott Pier, Christina Pier Landis, Dawn Tuel, Gina Pavoni Daly '93, and the Columbus Alumnae Club.

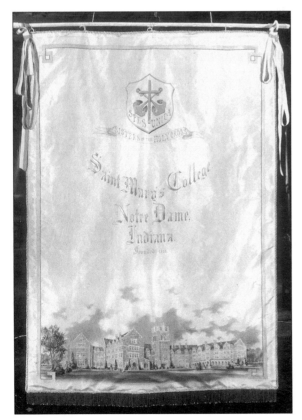

In 1930, this banner was donated to the Library of Louvain University in Belgium. Saint Mary's College was one of the 150 American universities, colleges, and preparatory schools that helped to rebuild the library, which had been destroyed in 1913, during the German drive toward France. In return for the generosity bestowed upon Louvain, the library hung banners from each American institution in its 150-foot-long reading room.

INTRODUCTION

The story of Saint Mary's College has previously been told only through text and timelines. *Saint Mary's College* is the first pictorial history utilizing many of the students' own photographs and voices. This book gives us the opportunity to see through their eyes what Saint Mary's was and what it has become.

In 1844, Father Sorin, C.S.C., and four Sisters of the Holy Cross began a novitiate school that would eventually develop into Saint Mary's College. The school was originally located 6 miles north of the University of Notre Dame in Bertrand, Michigan. The house was rented, and the school had only four orphans for pupils. By the 1848 commencement exercises, the novitiate was formally recognized as Saint Mary's Academy.

The school's reputation began to grow, as did its enrollment, and with them the campus. While in Bertrand, the original buildings had to be expanded several times to accommodate the growing needs of the sisters and students. By the time Saint Mary's moved to Notre Dame, Indiana in 1855, the foundations of the academy were firmly established, but more foundations for buildings had to be laid in the decades to come. The academy continued to add to its courses of study, enhance its Conservatory of Music, and be lauded for its excellence in intellectual instruction, artistic training, and spiritual development throughout the last decades of the 19th century. As its name, and what it stood for, became more well known and spread to greater distances, hundreds more families entrusted Saint Mary's Academy with the formation of the minds and hearts of their daughters.

Societal attitudes toward the education of girls, what they were taught and why they were taught it, did not always match Saint Mary's philosophy of education. The sisters knew that regardless of one's work or station in the world, there was a life of the mind that must be nurtured. Cultural and vocational education were celebrated and explored as halves of a whole, complementing and completing one another.

Saint Mary's has been a sister's school, an academy, and a college over its 156 years. Its official recognition from the State of Indiana as an academy came in the form of a charter as well as the power to confer degrees in 1855. As the students progressed from grade to grade, so, too, the school was able to progress with them. Elementary students were present on campus along with high school students and collegiates until 1945, when the Minims and Academy were moved to a separate site, leaving the college to itself.

Education at Saint Mary's was not just focused on development of the mind. The appreciation of religious principles and moral worth was taught to students from all denominations. Time and space were both structured to create an atmosphere where

self-evaluation, conversation with God, and faith in action were all fostered.

An effort was made to enhance the student's mind, body, and spirit in every facet of her education. Daily walks down the Avenue were as important as daily mass. The balance between individual effort and espirt de corps, strategy and instinct, and grace and strength were all cultivated through the progressive athletic classes and recreational activities.

The activities in which the students participated were regulated by the daily timetable. Bells aggressively announced the beginning of the day, and sleepy-eyed students would make their way to morning mass. Meals, classes, mail time, visits, clubs, and walks to the candy store were all scheduled with great regularity. Equally as regulated were the wardrobes they sported, the meals they were served, and the rooms in which they lived.

Lest this description lead one to think life at Saint Mary's was so regimented that it confined the spirits of the lively young women who lived there, the photographs reveal this was hardly the case. Silly shenanigans, heartfelt scenes of friendship, and energetic competitions were everyday happenings on campus and were snapped to become treasured mementos. Unfortunately, the pictures could not record the laughter along with the smiles, but the happy voices can be heard in the poetry and prose of the day.

Just as the church is not a building, but rather the people who fill it; Saint Mary's College is not the campus, but the women who have walked the Avenue. The alumnae have impacted the world as well as the college itself. The combined efforts of the Sisters of the Holy Cross, faculty, staff, and alumnae have helped Saint Mary's develop into one of the top liberal arts colleges in the Midwest. This pictorial history illustrates where Saint Mary's has been, but can only suggest where Saint Mary's will go.

One
FOUNDATIONS

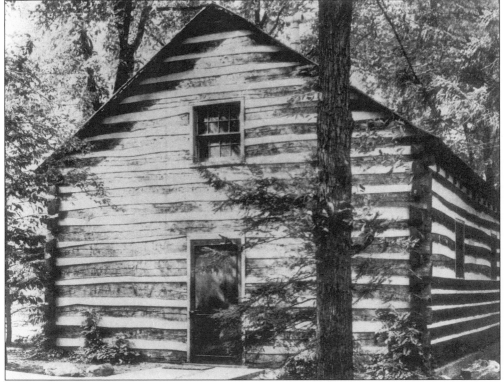

When the original four Sisters of the Holy Cross arrived from France in 1843, they lived in a dilapidated log shelter while a second story loft was built for them in the log chapel at Notre Dame du Lac. Their new accommodations still left something to be desired, as they could not stand up straight because of the low ceilings. The following year, another three sisters from France joined them.

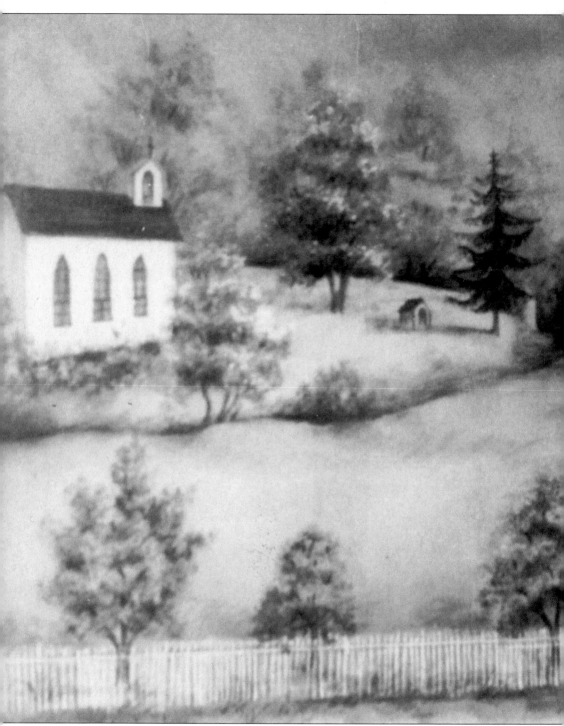

This illustration of the east view of St. Mary's Academy in Bertrand, Michigan, shows the school's first location. The 1850 *Prospectus* describes the campus as "beautifully situated in a healthy and pleasant location on the bank of the St. Joseph River. . . the grounds slope gradually to the clear bright waters. . . ." The house on this site, which is still standing

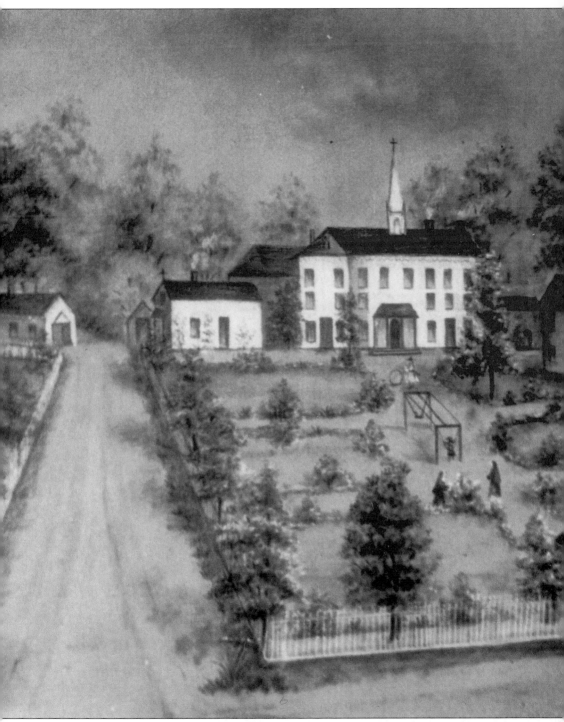

today, was first rented and then purchased from Joseph Bertrand for the "sisters' school." At first predicted to fail because of the low number of Catholics in the then-wilderness of the region, the school began to grow, adding more property and facilities along with pupils.

After weathering the first unstable year at Bertrand successfully, the school began accepting borders. Over the next few years, the housing conditions and academic facilities became inadequate to accommodate the increase in students. An existing frame building on the property that was donated by the citizens of the village of Bertrand was renovated and dedicated to "Our Lady of Seven Dolors" in 1846.

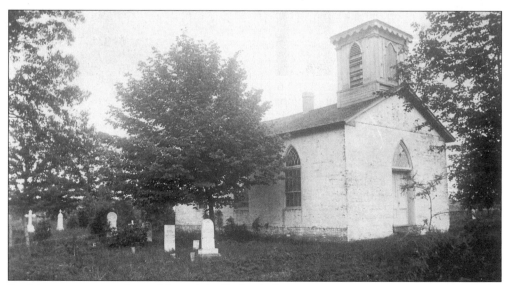

In this same year, a log cabin originally built for Native Americans was moved to the north end of the house and converted into the first chapel at Bertrand. A blacksmith's shop was purchased for $5 and remodeled to house an office and interview rooms referred to as the "parlor."

Originally forced to found the school 6 miles north of Notre Dame across the state line because of diocesan politics in Indiana, Fr. Sorin, the founder of Notre Dame du Lac and the novitiate that became Saint Mary's Academy, later understood the necessity of moving Saint Mary's because of hostilities from the Diocese of Detroit. In 1855, negotiations to purchase 185 acres, 1.25 miles west of Notre Dame were completed. After the new site had been cleared, the main building and the blacksmith's shop were drawn from Bertrand by oxen to a new foundation where they were joined with Holy Angel's Academy, a building from Mishawaka, Indiana. In September of that year, the buildings were dedicated as one under the name Saint Mary's of the Immaculate Conception. The winter of 1855 was formidable, and the new campus was threatened both from the heavy snow and the risk of fire from the stoves that heated the dormitories.

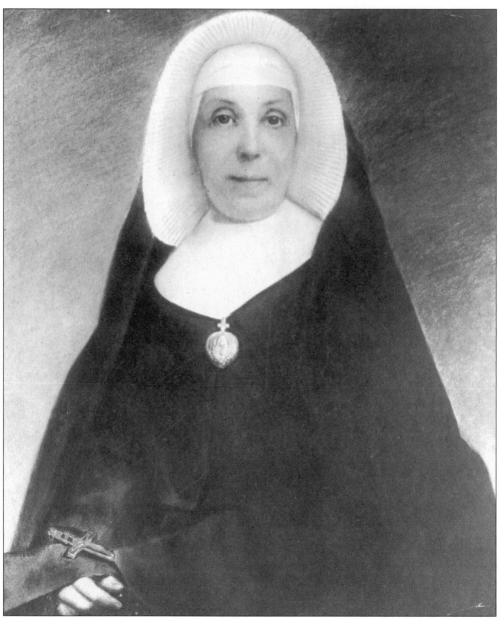

Mother Angela, the first American Superior General of the Sisters of the Holy Cross, was directress of the Academy from 1854–1870, and then again from 1886–1887. Eliza Gillespie became Sister Mary of Saint Angela when she made her vows in France in 1853, at the age of 29. Her many active years in society gave her exposure to and made her proficient in politics, hunting, boating, riding, dancing, sewing, fund raising, teaching, business, and management. The underlying current beneath all this activity was her faith, which eventually led to her vocation. Bishop Richard Gilmore said at her funeral, "How many there are among us here today whom she has molded, attracted, inspired with high and religious ambition; whom she has led in the paths of life! She has lifted up the weak, and made stronger those who were strong; soothed the wounded, directed all to the nobler and higher aims" (*Panorama* p. 40).

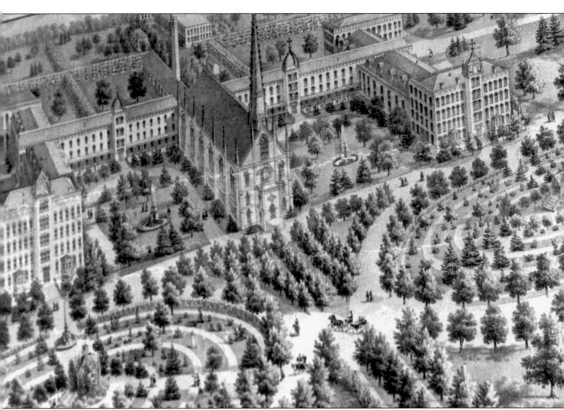

This artist's rendering was a vision for the growing academy. In 1844, the first students were two orphan girls taught while the nuns were making their novitiate in Bertrand. In 1846, eight students were under the care of the sisters, and by 1850, the enrollment had grown to 50 pupils. Seventy borders were housed at the new Indiana site in 1855. From 1865–1880, Saint Mary's Academy served an average of 250 students annually. To accommodate the physical, spiritual, and academic needs of the school, a four story main building was constructed in 1861–1862. Originally called The Academy, the structure served as the main building on campus for 40 years. This was one of the elements in the artist's drawing that became a reality, along with Trinity Arbor, and the Avenue. While the central focus of the illustration is the church, it was not until 1885 that the Church of Loretto was completed.

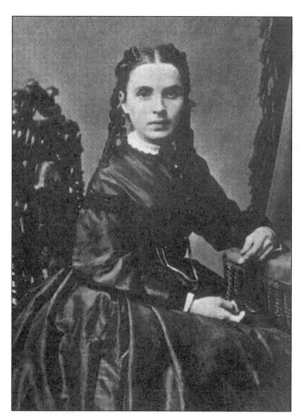

The year 1848 was a year of firsts; the name Saint Mary's Academy became official, and the first commencement in Bertrand was held. Two years later, the laws of the State of Michigan recognized Saint Mary's as an academy. The articles of incorporation were dated February 28, 1855, in the State of Indiana. This empowered the school to grant degrees; however, the first degree was not bestowed until 1898. The first valedictorian, Mary Elizabeth Dennis McMahon, class of 1860, is pictured here.

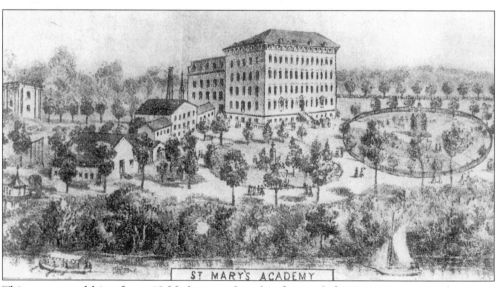

This copper rubbing from 1866 shows a decade of growth for Saint Mary's. At this time, the original buildings moved from Bertrand still stood; the Manual School, the Academy, the Chapel of Loreto, and Rosary Circle had been added. This is a more realistic, even rustic, illustration of the academy than the grand vision in the previous drawing.

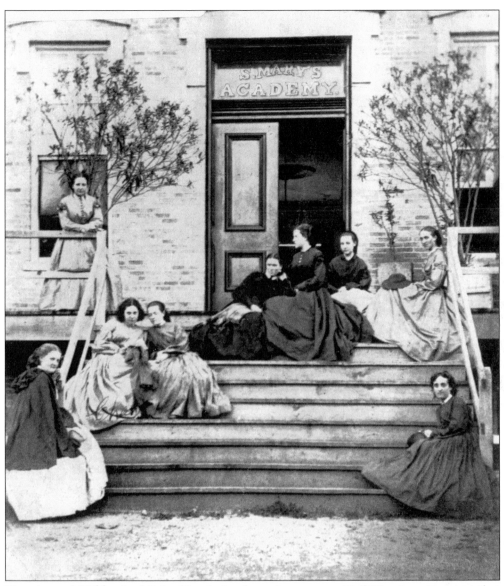

The class of 1866 exited Saint Mary's Academy into a post-Civil War America—not that the students' lives were untouched by the war while they were within the convent gates. General William T. Sherman's wife, Ellen Ewing Sherman, was Mother Angela's cousin. Because of this family connection, their daughter Minnie attended Saint Mary's during this time. The school was also refuge to the daughters of Southern sympathizers. Try as the sisters might, it was not always possible to maintain an atmosphere of neutrality among its students from the North and South. Throughout the war years, Saint Mary's saw a continuous increase in enrollment. In 1862, 105 students were attending the school, and increased by 27 students the following year. By 1864 there were 150 students, with an additional 115 enrolling the following fall. This surge in students extended the sisters diplomatic energies to their greatest extent. "Even if enduring links of peace could not be forged, overt juvenile battles were at least prevented" (*Panorama,* p. 31).

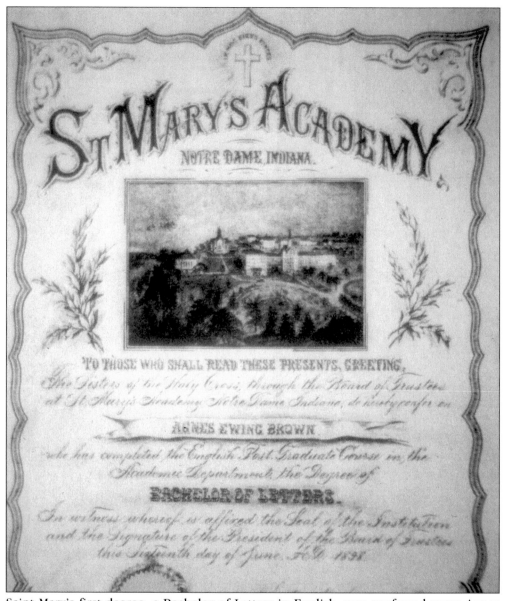

Saint Mary's first degree, a Bachelor of Letters in English, was conferred upon Agnes Ewing Brown in 1898. She took classes in philosophy, math, French, Greek, Latin, and wrote her thesis on pedagogy. Later, she earned a Bachelor of Science degree from South Dakota University, and received her Master of Arts from the University of Michigan. The November 1896 issue of *Chimes*, a student literary magazine, printed a sample of her poetry. "I stood by the river, one autumn day,/And watched the falling leaves float by;/ And over the waters the sunshine lay,/A mystic glory that charmed mine eye./And I thought what a pleasant thing 'twould be,/ To idly float down the stream of life,/ Wherever the current drifted me,/ My course with the sunshine of joyance rife./ When I saw in the midst of the broad expanse/ A lonely rock of gray,/And the wave that methought could but ripple and dance,/Were fiercely beating its life away./ And I thought what a noble thing 'twould be/ To stand thus firm against a tide/ Of wrong from sin's dark, surging sea,/ If truth and right with me abide."

18

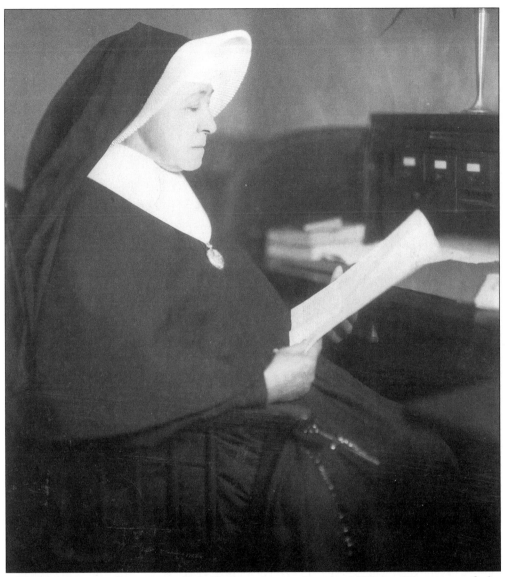

When Mother Pauline succeeded Mother Annunciata in 1895 as Directress of the Academy, a division was made between the Superior General of the Sisters of the Holy Cross and the office of the directress. Mother Pauline's term as the first president of Saint Mary's Academy extended from 1895 to 1931. In addition to the physical improvements to the school, Mother Pauline also increased its academic excellence. She amended the College Catalog in 1895–1896 (and again in 1911) to better communicate her philosophy for a Saint Mary's education; defined a one-year post-graduate program, which resulted in the conferring of degrees in 1898; reorganized the undergraduate curriculum by 1903, and clearly distinguished the Academy from the College; brought to campus such notable lecturers as William Butler Yeats, William Howard Taft, Henry James, and Eamon deValera; applied for and received accreditation for the college with five different accreditation agencies; ensured that scholarships and student aid were available despite the financial strain of construction; and added new courses to the curriculum such as pharmacy, sociology, and journalism.

ST. MARY'S COLLEGE AND ACADEMY
Conducted by the Sisters of the Holy Cross

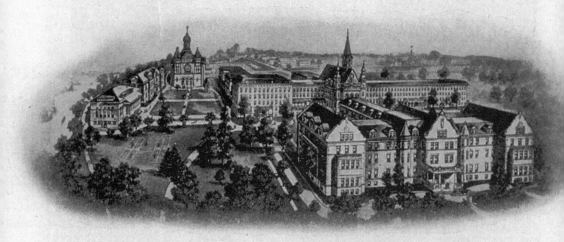

BIRD'S-EYE VIEW SAINT MARY'S

St. Mary's

Now in the 57th year of active educational work. St. Mary's Academy for Young Ladies has justly earned the reputation of being one of the most thoroughly equipped and successful educational institutions in the United States. The Academy buildings—large, well ventilated, commodious, heated with steam, supplied with hot and cold water, and with fire escapes,—are beautifully located on an eminence overlooking the picturesque banks of the St. Joseph River, in the highest and healthiest part of the State.

Courses of Study

All the branches of a thorough English, Classical and Commercial Education are taught by a competent faculty. French, German, English, Greek and Latin are taught without extra charge. Stenography and Typewriting extra.

The Conservatory of Music

Is conducted on the plan of the best Classic servatories of Europe. Three instrumental and one in theory are included in the regu ition; extra practice pro rata.

The Art Department

Embodies the Principles that form the b instruction in the best art schools of Pupils may pursue a special course in the of Painting and Music.

Minim and Preparatory

Pupils of tender age, and those who need training, are here carefully prepared for th demic and Collegiate Courses. For Catalog taining full information, address

The above advertisement, which graced the inside cover of the *Chimes* during the 1910s, gives witness to the growth the school experienced over its then 57 years at the Indiana campus. The original Bertrand buildings had been razed, Academy (1862), Lourdes (1871), Saint Angela's (1892), Augusta (1893), St. Joseph's (1901), and Collegiate Halls (1903) can all be seen in addition to the Tower Building (1889), Church of Loretto (1885), farm buildings, and tennis courts. The academic program had also grown by the time this advertisement was published. The original Academy had added "advanced courses" by 1895; these developed into the three college courses offered—English, classical, and scientific. The Academy still offered a "generally well-rounded academic training" in its college preparatory area, and the art and music departments had expanded to include instruction for a greater variety of instruments and media (*College Catalog,* 1911).

20

The Tower Building was built onto the north side of Lourdes Hall in 1889. The bells for the clock inside the tower were sent from France in 1844, and still ring over the campus. The Tower Building was just one of the many improvements made under Mother Augusta's term as mother general. It was during her era that cement sidewalks were laid between all the buildings and also along the riverbank.

By 1874, the wooden steps on the Academy building were replaced by a porch with wrought iron railings, as seen in this undated photograph, and served as the setting for many class pictures like this one. Here, some of the girls are wearing the medals that were awarded each year for academic excellence.

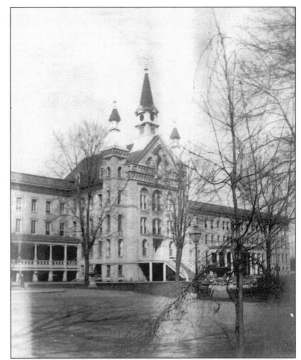

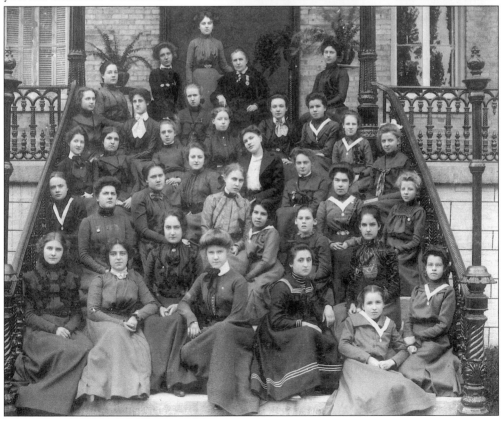

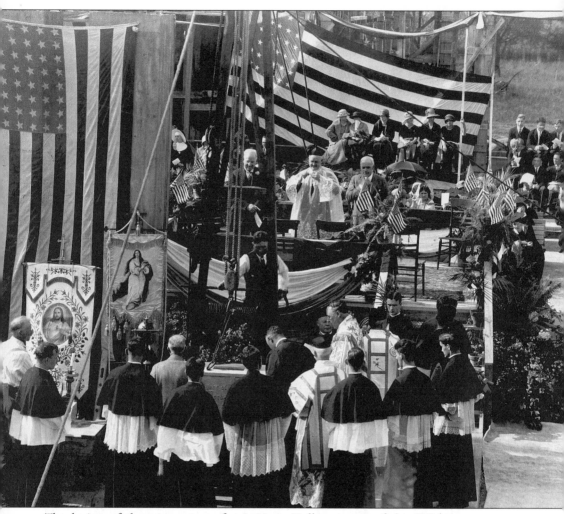

The laying of the cornerstone for LeMans Hall was part of the 1924 commencement exercises. Planning for the project proceeded, despite fundraising difficulties, which up to that point had only raised $100,000, a mere 15 percent of the estimated $1,500,000 needed. The plans themselves also encountered difficulties. Approval had been granted only for a residence hall, not a multi-purpose building with dining, classroom, and library facilities in addition to student housing. Collegiate Hall already housed these things, and the College and Academy simply shared them. Mother Pauline took the North Central Association's accreditation comments to heart, and foresaw the need to physically separate the two schools and persistently resubmitted plans for a self-sufficient building for the College. In 1945, a further separation of the College and the Academy was made when the Academy was moved to the Erskine Estate, of the former president of Studebaker on the south side of the South Bend. A.R. Erskine himself was at the above cornerstone ceremony, as were the Moreau and Holy Cross Seminary choirs who can be seen in the background.

Two

LIFE OF THE MIND

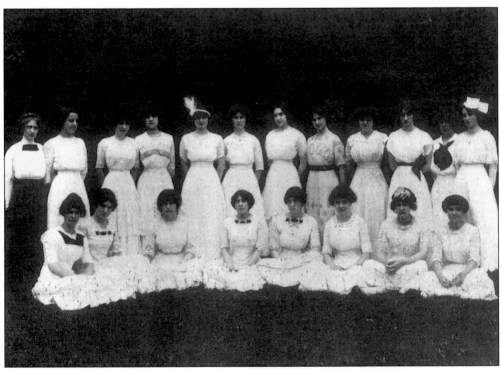

The Academic Department of 1912 was the graduating high school class from Saint Mary's Academy. The class exercises were held on June 8, 1912, in Assembly Hall and featured recitation of essays, and vocal and instrumental numbers. These exercises gave the students a chance to demonstrate their abilities to family and friends.

The "practical art" of typewriting was taught at Saint Mary's as early as 1886. According to the 1900 *College Catalog*, the girls were taught by skilled instructors on Remington typewriters. Seated at this new technological advancement is Margaret Munger Black, class of 1886, a future member of the Canadian Parliament.

Saint Mary's has always seen the wisdom of balancing its cultural and vocational courses. While it went without saying that philosophy, religious instruction, and Latin were all extremely valuable for a holistic education; it was equally valuable to possess skills that could be applied in the work-a-day world, such as typing. For an additional charge, students could avail themselves of the opportunity to learn Graham's system of stenography.

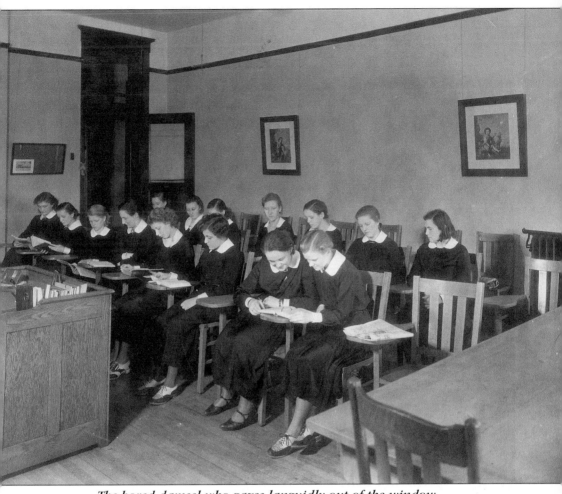

The bored damsel who gazes languidly out of the window.
The active member who has just provoked a smothered giggle from her seat mate.
The self-conscious Freshman who has just arrived minus excuse and collar.
The napping lass, the product of a midnight "feast."
The harassed one who sits in dread of being called upon.
The pessimist who continually finds the assignments too long.
The juvenile artist, deeply engrossed in outlining fraternity pins.
The fastidious one, invariably affected by the temperature of the room, who keeps
the window-pole constantly in motion.
The balance of the class who are making desperate attempts to grasp the knowledge
being bestowed upon them (Academic Annual, 1923).

While on the surface so many things have changed between 1923 and 2000, the poem
is as representative of student thought today as it was then.

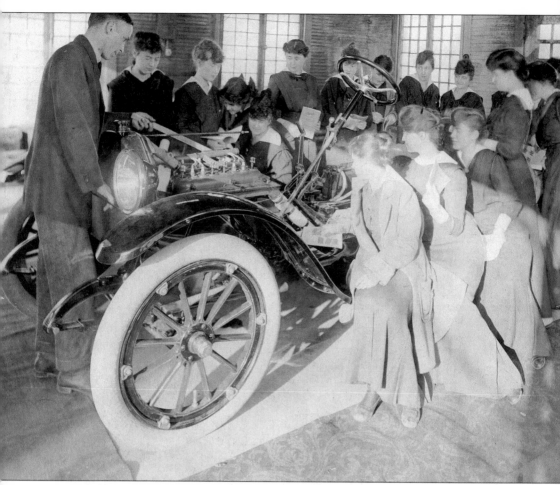

Miss Mary M. Callahan, an athletics instructor, suggested to Mother Pauline in 1914–1915 that a course in automobile mechanics be developed, "as an incentive to the college girls to learn to operate their cars with intelligence." Mother Pauline, in her "progressive conservative" manner, agreed, and sent Miss Callahan to a crash course at the Studebaker plant in Detroit, Michigan. Upon her return, classes were organized. They were held in the Canoe Club House where the chassis that had been donated by Studebaker president A.R. Erskine was stored. Instruction was given by both Miss Callahan and Mr. John Seibert, the college chauffeur. Demonstrations and lectures imparted knowledge of mechanics to the students, who were required to pass both written and oral examinations. In addition to theoretical knowledge of the automobile, practical experience was also available through driving lessons with Miss Callahan. The May 1935 *Courier* closes its article on the course with, "What jeopardy threatened the college automobile during those trial excursions perhaps only St. Christopher knows!"

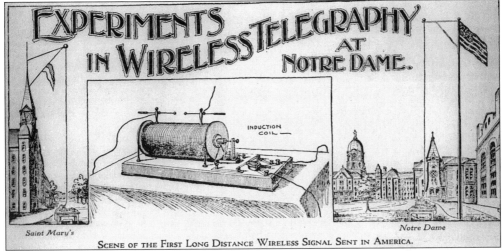

Saint Mary's

Notre Dame

SCENE OF THE FIRST LONG DISTANCE WIRELESS SIGNAL SENT IN AMERICA.

Continually on the cutting edge of technology, Saint Mary's College played an integral role in the development and use of the wireless telegraphy. On April 19, 1899, the first distance message sent over land, and the first in America, was transmitted in Morse code between Saint Mary's and Notre Dame. The induction coil used in the experiment belonged to the college and the magnetic impulses were received by equipment on the front porch of the convent.

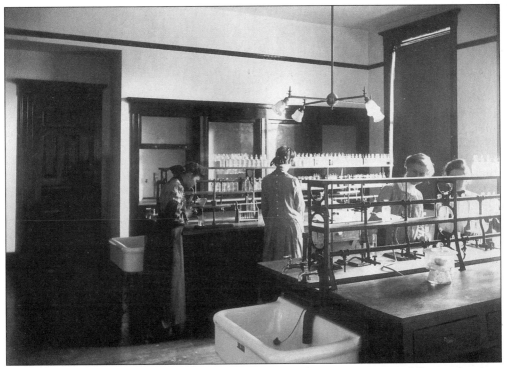

In 1851, among other sciences, both botany and geology were required for graduation. Each course lasted five months and ended with a two-hour public oral exam. In 1870, astronomy was added. In 1903, the first bacteriology course of its kind in Indiana was established at Saint Mary's College.

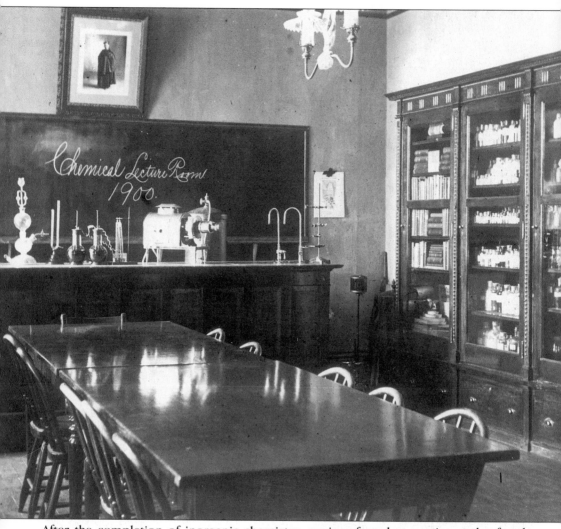

After the completion of inorganic chemistry, seniors found a creative outlet for the knowledge they had so recently acquired with "the explosion of gun-powder, gun-cotton and smokeless powder, while Greek fire and varied pyrotechnic displays made up the rest of the brilliant programme" (*Chimes,* 1898–99). Undoubtedly, the students practiced these techniques during their lab periods, as postgraduate science courses required laboratory work beginning in 1890–1891. By 1917–1918, four courses in chemistry were offered: general chemistry, advanced inorganic and quantitative analysis, qualitative analysis, and elementary organic chemistry. The Collegiate Hall laboratories that were state-of-the-art in 1903 were used for these four courses as well as for all subsequent labs until the new Science Hall was constructed in 1954. In 1955, the 150 students enrolled in biology/chemistry comprised 18 percent of the student body. It is not surprising then to learn that five years later more space was required for the chemistry department, and proposals were sent to the administration for expansions.

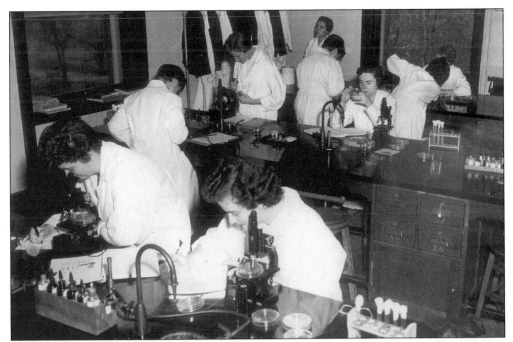

The laboratory space made available upon the completion of Collegiate Hall in 1903 had to have been much appreciated by those students working toward their four-year Bachelor of Science degree. The next year, a class in pharmacy was introduced for the first time and was eventually offered as a four-year degree in 1919–20.

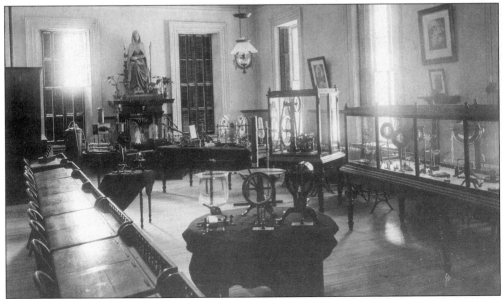

The original science halls were in Academy Hall and then Collegiate Hall. As early as 1898, the college held a fine inventory of state-of-the-art scientific equipment "illustrating the laws of sound, light, electricity, heat and magnetism, as well as the principles of mechanics" and "Roentgen ray experiments, pneumatics, hydrostatics, and hydrodynamics" (*College Catalog*, 1898).

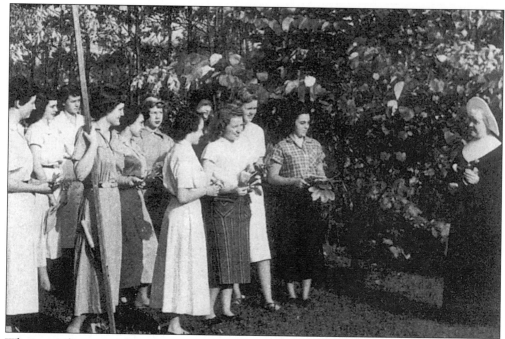

What was the surest sign that spring had finally arrived at Saint Mary's? Not the robins in the trees, but rather the botany students wandering the paths and lawns gathering specimens. The items they collected were classified for their herbarium of flora of Northern Indiana.

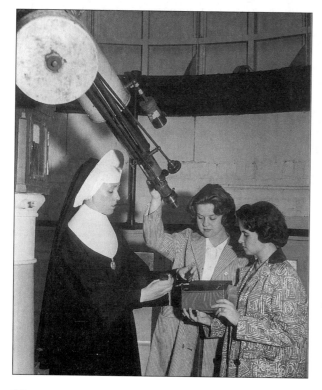

The 1863–1864 *College Catalog* mentions that one area in which scholarships were offered was "astronomy with the use of globes." Beginning in the 1870s, astronomy was a required course for graduation. An alumna from the class of 1871, Augusta Sturgis, went on to teach the course after she became Sister Eleanor, C.S.C. (though she preferred philosophy). *Brocklesby's Astronomy* was used as the textbook for approximately 30 years beginning in 1851. In 1919–1920, the college still offered a course in advanced astronomy.

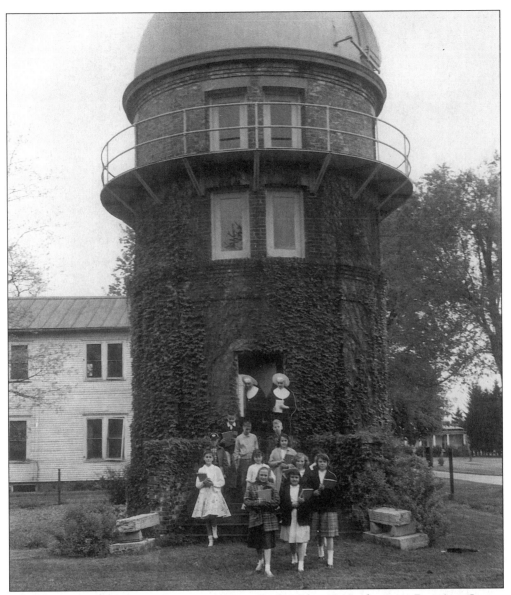

The Astronomical Observatory was a memorial to the 1915 Alumnae Reunion. It was built of brick, concrete, and steel. The dome was 18 feet in diameter, and housed a 6-inch equatorial telescope. The star gazers on campus who much anticipated the building's opening must have been a little disappointed that they were allowed to see only the first few constellations visible at twilight, as students were not permitted out of the residence halls after dark. During World War II, naval units from Notre Dame used the observatory for special training. After the observatory was razed, the dome was relocated to the ECDC playground.

On this site in 1965, the Congregation of the Sisters of the Holy Cross constructed Regina Hall "as a house for postulants and young sisters" (*Panorama*, p. 170). The building contained its own chapel, offices, classrooms, social space, and dormitories. In 1969, the Congregation agreed to lease the hall to the college, who needed it to accommodate its growing student enrollment.

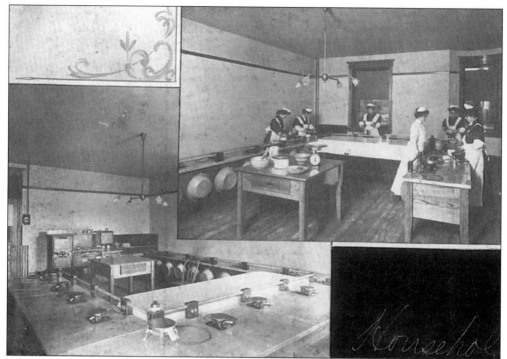

Perhaps a degree in domestic science does not sound as academically challenging as the rest of the courses offered at Saint Mary's, but upon closer inspection of the required classes one would be inclined to change one's opinion: bacteriology, physiology, physics, botany, chemistry, psychology, logic, pedagogy, and physical training.

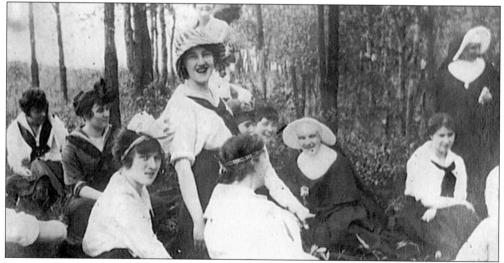

At the end of the year, domestic science students would apply the skills they learned in their courses by preparing and serving formal luncheons for themselves and friends. Some classes enjoyed picnic lunches along the banks of the St. Joseph River. This turn-of-the-century photo was taken in Pearley's Glen, a lowland area on the southern edge of campus.

Reidinger House was officially opened as a "model house" in 1939. The family of Adaline Crowley Reidinger, class of 1864, and Adelaide Riedinger, class of 1889, were the major contributors for the building. The design of the house allowed students to apply the domestic science knowledge they had learned in a practical setting.

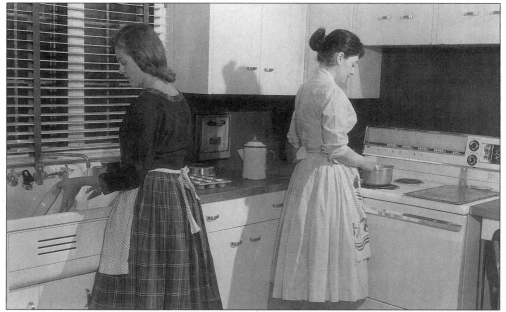

In 1903, the Domestic Science Department was established at Saint Mary's. Although the classes were not formalized into a department until this time, sewing, cooking, and homemaking were always offered. In 1910, the school made the distinction between sewing, which became domestic art, and cooking, which remained domestic science. It was not until 1914 that a degree in household arts was offered.

During World War I, in response to the government's calls for practical aid to the cause, Saint Mary's offered new classes in thrift and the conservation of food. Herbert Hoover, then Food Administrator, wrote a letter of thanks to Mother Pauline for the college's willingness to participate. During this time no refreshments were served at social functions, additional meatless days were observed, and war bread was served.

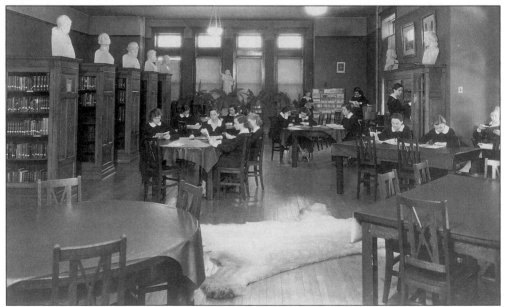

Academy Library was housed in Collegiate Hall from 1903 until 1925. It was the college's first recognized library and eventually held seven thousand volumes in addition to bound magazines and encyclopedias. There was a separate Seniors' Reading Room where students could spend appointed hours everyday enjoying current magazines of literary worth.

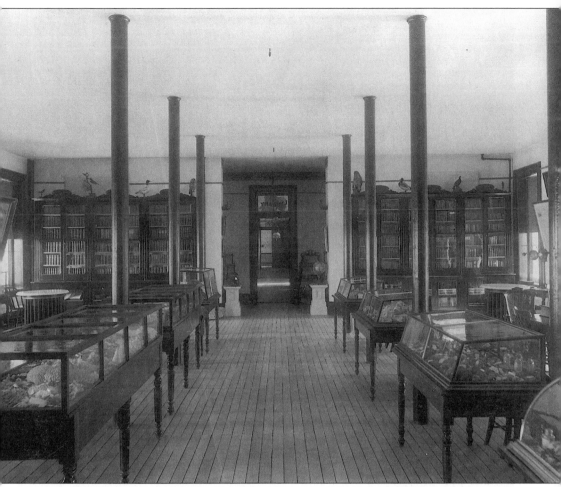

The very first library was a shelf in the wood frame building on the Bertrand site. Once the college moved to Indiana, each department had their own special library of reference books, and there was also a general library in Academy Hall. It was moved to the west wing of the Music Hall in 1867. The collection undoubtedly included many volumes entirely in French since students were required to read essays in it aloud, and Mother Angela was said to speak it effortlessly.

Also seen in this picture are the cabinets for the museum of "geological, mineralogical, zoological, and botanical specimens, besides curios from all lands" (*Chimes,* 1893). These collections, which were student-created and student-maintained, classified the various collected samples from each discipline mentioned above. In 1912, Rev. Father Fallize, C.S.C., donated a much-appreciated gift of an Indian silver ash tray and match box set to the museum. The museum was one of the stops on commencement day tours.

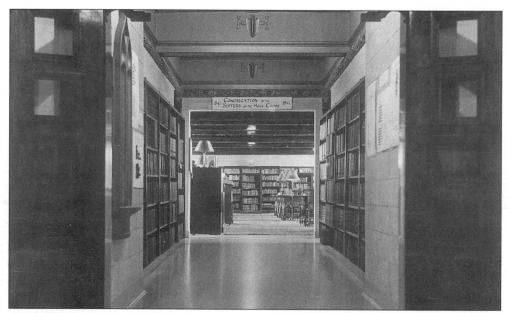

The library was moved to the "new campus" in 1925, and occupied the central wing of the second floor (now Queen's Court). The space in Collegiate Hall where the library used to be was later renovated to become Sacred Heart Chapel. In 1938, the departmental and general collections were merged and catalogued using Library of Congress classification.

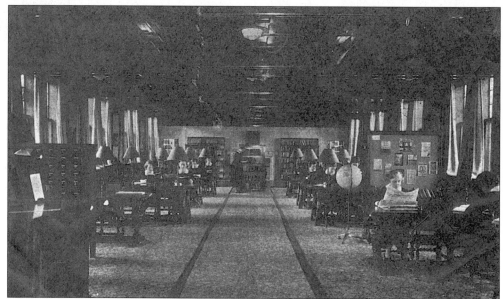

Panorama, a history of Saint Mary's College, states that an unsatisfactory report from the American Association of University Women (AAUW) in 1932–33 sited that the library offered poor service and substandard equipment. The library moved to a new building in 1942, leaving this space in LeMans free for the art department. Sometime after 1945, the art rooms were moved elsewhere, and the Queen's Court area was converted into bedrooms.

The Alumnae Centennial Library was named to commemorate two notable events. The first was to recognize the fundraising effort organized by Saint Mary's alumnae for the new building to be constructed. The second was to honor the 100th anniversary of the founding of the Congregation of the Fathers, Brothers, and Sisters of the Holy Cross in France. The building itself manifests the college's connection to its roots through its French Provincial style. By 1951, the new library housed 44,000 volumes and was in the top five percent of all college and university libraries in the country by 1963. Within the next decade, the library had exceeded its capacity, and ten thousand books and nearly seven thousand bound periodicals had to be housed in three campus halls. The scattered holdings did not hurt the library's rankings, but the college came to the realization that there was a desperate need for a newer and larger library, thus leading to the construction of the Cushwa-Leighton Library.

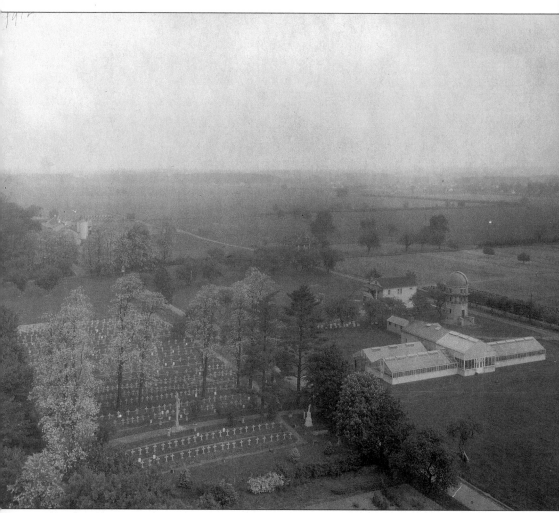

The greenhouse, erected in 1914, allowed the students' hands-on experience to remain an integral part of class instruction even in the winter months. Otherwise known as the "propagation house," the greenhouse sheltered more than 30,000 plants, most of which were exotic. The middle portion of the building was reserved for the conservatory of ferns replete with pineapple and banana plants. The roof over this middle section was made of ground glass that broke up the sun's rays to protect the ferns. The poinsettia parlor, which was located in the west wing, shared space with the orange and lemon trees as well as the fuchsia plants. On the opposite side was the chrysanthemum drawing room. The Easter lilies and carnations were also grown in this area. The combination of sunlight, heat from the boilers, and soft water created an ideal growing environment. The greenhouse was razed in 1957, and Regina was later built on that site.

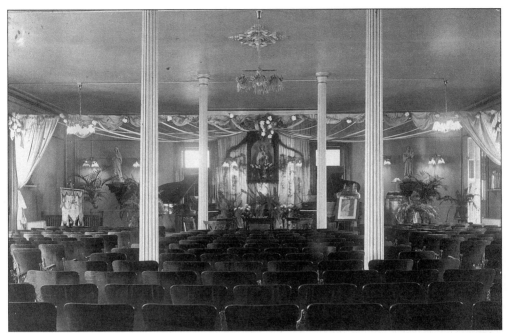

Assembly Hall is located in Lourdes Hall. Built in 1871–1872, Lourdes adjoins the Music Hall, which is north of the Academy (now Bertrand Hall) and also houses the dormitories that were used for the Minims. Assembly Hall was once the scene of the many concerts, lectures, programs, and meetings that occurred throughout the academic year.

Cooperation between Saint Mary's College and the University of Notre Dame extended beyond the dance floor. In the late 1940s, town hall meetings, symposiums, debates, dramas, and radio and television technique classes and programs were some academic activities in which students from the two institutions shared. In the spring of 1965, a formal co-exchange program was begun, much to the delight of students on both campuses.

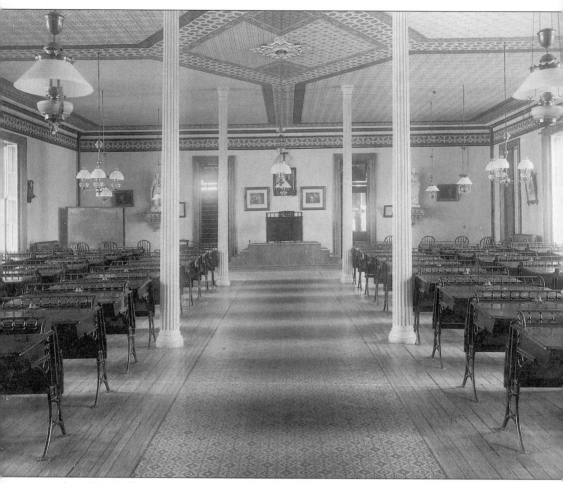

In the 1911 *College Catalog,* Mother Pauline wrote, "[Education] stands for the highest development of mind and heart, and aims to make its students women of ideas rather than women of mere accomplishments, to bring them into personal relation with wider worlds, larger life, by placing before them truth as it may be apprehended, truth in its various aspects—literature, history, science, and art." One of the ways students were able to become personally related with literature was through student literary publications. The *Rosa Mystica* was the first such magazine at Saint Mary's, and was published from 1859–1888. *Chimes*, the weekly literary periodical, began in 1892, with the purpose "to promote the advancement of all that is good and noble in the heart of every pupil at Saint Mary's; to elevate their standard of literary taste, and to serve as an incentive to earnest persevering labors in all that pertains to a thorough Christian education" (*Chimes*, 1892). Clearly, Mother Pauline's 1911 educational philosophy was in keeping with long-held ideals at the school.

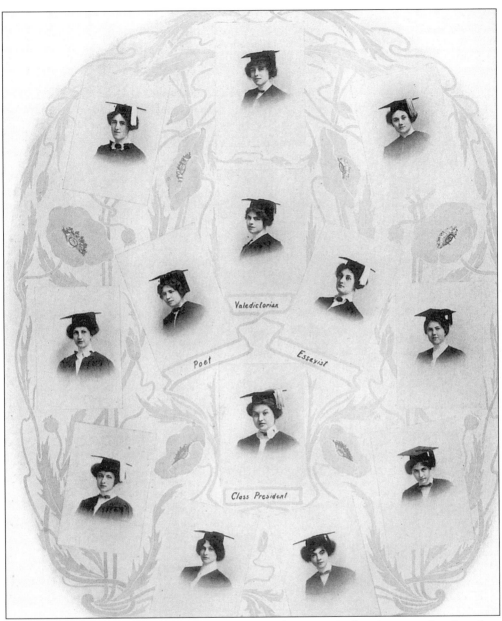

Commemorative photographs, such as this one from 1912, showing a graduating class entirely of women were not uncommon at that time period. As the century progressed, however, they became more and more rare as women's colleges underwent dramatic alterations. By 1969, in order to adapt to changing attitudes toward women and their education, many women's colleges had gone co-ed or had merged with men's schools. While Saint Mary's discussed a merger, it did not follow its contemporaries' strategies in order to stay a viable educational entity. Instead, it retained its original focus on women in part because it was "consistent in the belief that woman is the equal of man in human dignity and in all rights, but different from him in her particular qualities of mind and heart, often different from him in what she can contribute to a world in which both must live" (*Panorama*, p.xii).

Saint Mary's was one of the first colleges in the country to offer summer school. Professors from Cornell, Columbia, Michigan State Normal School, Notre Dame, and the Chicago School of Music all lectured during the summer sessions. These courses delighted many students since they did not always return home for the summer months.

Because of the demands of the budget and time, there were never enough sisters to fill all faculty positions. When Eliza Allen Starr joined Saint Mary's in 1848, she was one of the first lay instructors. By 1961, the college catalog listed faculty from 31 of the most prestigious colleges and universities in the United States and Europe.

In 1956, Bruno Schlesinger founded the Christian Culture Department, which is now known as the Humanistic Studies Department. The students studied non-Christian and Eastern influences on the history of ideas and Western civilization through arts, theology, literature, and philosophy. On April 25, 1985, to commemorate the first endowed chair at the college, Dr. Schlesinger was presented with a medal.

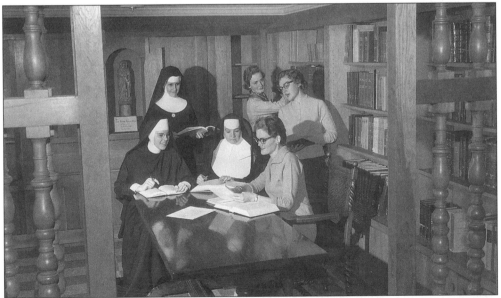

In 1942, Sister Madeleva established a Graduate School of Sacred Theology. There was a doctorate degree in sacred theology, and a Master of Arts degree in sacred doctrine in religious education. The lack of funds and the opening of a graduate school of theology at Notre Dame contributed to the closing of the department in 1967. Pictured here is the Saint Thomas Aquinas Room in the Alumnae Centennial Library.

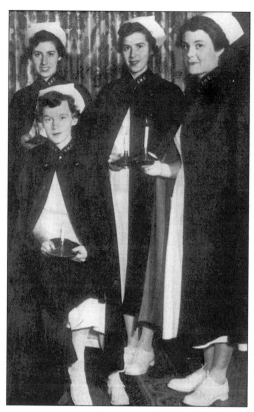

Sisters of the Holy Cross worked as nurses in the Civil War and were the forerunners of the Navy Nurse Corps. Nursing became an academic department in 1934. Students were required to take two years of liberal arts education and three years of professional training before graduating with a Bachelor's degree and accreditation as registered nurses.

In 1906, Saint Mary's received accreditation from the North Central Association of Colleges and Secondary Schools. By 1931, it held membership in the Catholic Education Association, American Council on Education, American Federation of Arts, and the International Federation of Catholic Alumnae. Later, Woodrow Wilson and Fulbright Scholarships and grants from the National Science Foundation gave evidence of the outstanding tradition of academic and cultural education that students received at Saint Mary's College.

SAINT MARY'S COLLEGE
NOTRE DAME, INDIANA

GRADUATE EDUCATION PROGRAM

SPRING SEMESTER Feb. 2 – June 3

Co-educational — Courses leading to Master or Arts in Elementary Education and Special Education. Afternoon and evening classes.

Registration — Saturday, Jan. 29, 9-12 noon, West Lounge, LeMans Hall; or by appointment, afternoons or evenings, Room 111 Moreau Hall (Monday, Jan. 24, thru Sat., Jan. 29, call 232-3381, ext. 273.)

Course		Hour and Day
ELEMENTARY EDUCATION		
Ed 222	Learning Process (2)	5:30-7:30 T
Ed 231	Research Seminar in Curriculum (2)	7:30-9:20 T
Ed 232	Action Research (2)	Arr.
Ed 295	Independent Study (1-3)	Arr.
SPECIAL EDUCATION		
SED 157	Speech and Language of the Mentally Handicapped (2)	7:00-8:50 M
SED 180	Health Problems of Exceptional Children (2)	5:00-6:50 W
SED 170	Reading Problems of the Mentally Handicapped (2)	7:00-8:50 M
SED 171	Techniques of Teaching the Mentally Handicapped Adolescent (2)	5:00-6:50 M
SED 282	Physiological and Psychological Bases of Mental Retardation (3)	7:00-9:50 W
SED 275	Independent Study (1-3)	Arr.
SED 290	Seminar: The Trainable Child (2)	5:00-6:50 W
ART		
Art 117	Drawing (2-8)	2:00-4:00 M-W-F
Art 119	Painting (2-8)	2:00-4:00 M-W-F
ENGLISH		
Eng 139	Writing Conference (1)	12:00 M
Eng 172	American Literature after 1860	5:00 T-Th
Eng 216	Applied Linguistics for Elementary Teachers (3)	6:00-8:50 M
HISTORY		
Hist 106	American Culture (2)	3:00 T-Th
Hist 132	History of Russia (3)	12:00 M-T-Th
Hist 160	Age of Conflict (3)	2:00 M-W-F
MUSIC		

First called a Bachelor of Arts in Pedagogy in 1915, the Bachelor of Arts in Education was granted in 1918, and continues to this day. In 1959, the National Council for the Accreditation of Teacher Education granted accreditation to Saint Mary's College. The NCATE is the national agency that certifies the quality of teacher education programs. The summer of 1965 was the inaugural year of the master's program in education. A Master of Arts in General Education and Master of Arts in Special Education were both available. The graduate program only lasted three years due to the lack of funding. A year after the graduate program ended, the Education Department began a new venture by aligning itself with the Notre Dame Institute for Studies in Education. Through this collaborative effort, Saint Mary's became responsible for the undergraduate teacher education program for both the University of Notre Dame and Saint Mary's College.

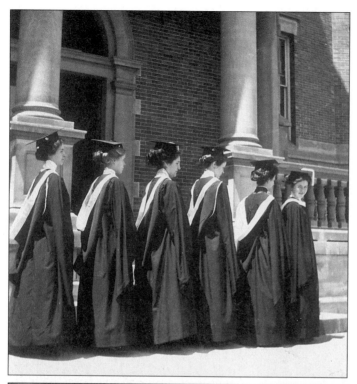

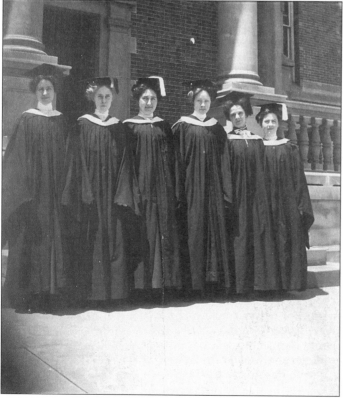

*Here's to our fair
Collegians,
the dearest and the
best,
With a spirit of golden
loyalty
O'er-powering every
test.*

*Here's to our gay
Collegians,
All joyous and free
from care;
May their lives outside
of S.M.C.
Continue as pure and
fair.*

*Here's to our brave
Collegians;
When they're called
still farther away,
May the triumph of
noble womanhood
Crown at the close of
life's day.*

—*A Toast* by Bertha
Broussard was taken
from the June 1914
issue of *Chimes*.

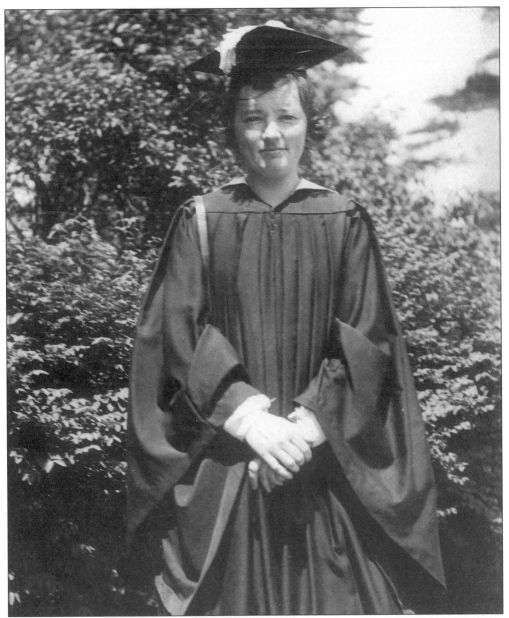

Commencement and all its related events had a personal as well as public significance. By 1870, the items a graduate could receive to commemorate her accomplishments were: a diploma, gold maltese cross, medals, premiums, crowns, and wreaths of honor. The gathering at Assembly Hall for the commencement ceremony itself was just one of the activities that drew capacity crowds to the campus each spring. Exhibitions of fancy work, oil painting, and recitation of essays (including those in French and German) were enjoyed by all. The editor of the *Catholic Review* writes in 1880, "I have visited Saint Mary's on many graduation days and testify of knowledge to the genuineness of the girls' essays. The ideas in the essays were sound, clear, practical, and . . . indicated good standards prevailed in everything—in the teachers' methods, in the pupils' habits" (*Benchmarks*, p. 35).

Sister Madeleva was one of the most well known presidents of Saint Mary's College. During her years as a student at Saint Mary's, she was especially well-known to the Dean of Discipline. Sister Madeleva is quoted as having said, "God did not make sisters out of girls like me." It was during her junior year that she finally decided that she would follow her vocation.

When Sister Madaleva was appointed in 1934, Saint Mary's had 21 sisters, 2 priests, and 21 lay professors, and slightly under 300 students. At the time of her retirement in 1961, the college had 1,100 students enrolled, 50 religious persons, and 72 lay faculty.

The year after her appointment as president, Sister Madeleva, with the help of Sister Frederick, Dean of Studies, composed the Saint Mary's curriculum around four themes: physical, intellectual, spiritual, and social.

Three

SACRAMENTS, SAINTS, AND SOCIETIES

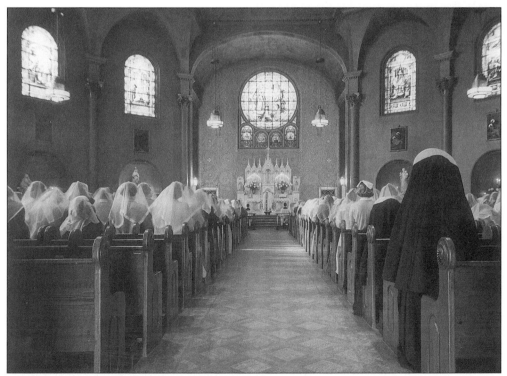

The school year officially opened with the Solemn High Mass of the Holy Ghost in the Church of Loretto with intentions offered for a successful school year "in learning and living the truth." At the end of October, three days were set aside for the Student Retreat. Classes were suspended and students spent their time considering spiritual growth, renewing resolutions, and adjusting perspectives (*Student Handbook*, 1959).

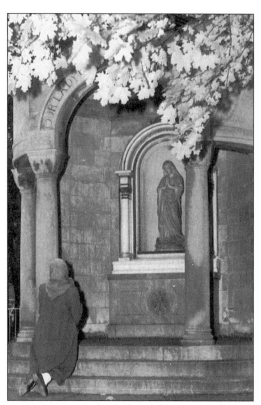

Some shrines on campus were: outdoor stations of the Cross, shrines to the Sacred Heart, Our Lady of Peace, Our Lady of Fatima, Saint Michael, and Saint Anthony. Saint Mary's has always created and maintained spiritual space to guide students in the appreciation of religious principles and moral worth, regardless of their religious denomination.

Few realize that it was once possible to enjoy a few peaceful moments in prayer and reflection at a grotto on the Saint Mary's campus. Even in Pearley's Glen, the students were "surrounded . . .by all that tends to elevate and ennoble" in order to "acquire greater love and veneration for all that pertains to a truly Christian life" (*College Catalog,* 1915).

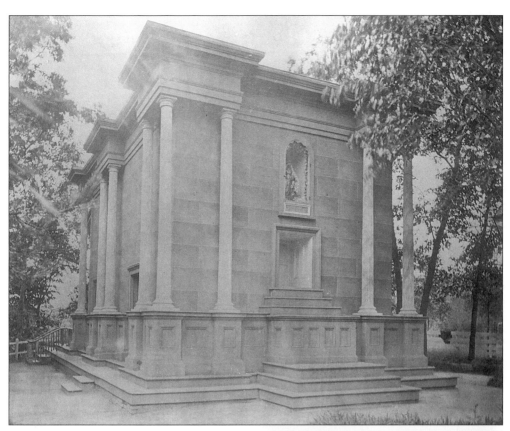

The first permanent spiritual space erected in 1859 on the Indiana campus was the Chapel of Loreto, a replica of the Holy House of Loreto in Italy. Saint Mary's students were so devoted to the Blessed Mother that they developed the custom of leaving their gold chains and college medals in the chapel, which were eventually melted down to line the tabernacle, leaving a single medal to commemorate the tradition.

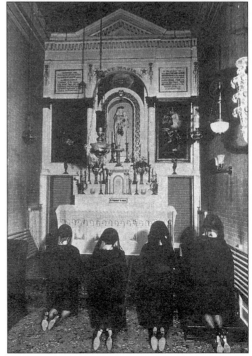

It is so quiet there; silence is everywhere,
You used to feel as safe and without fear,
When all your prayers were said,
And you were tucked in bed.
All pretense, and the mask that hid the
tear,
These must be left outside;
yourself you cannot hide,
It is so quiet there, and God so near.

—Marie McCabe, class of 1917.

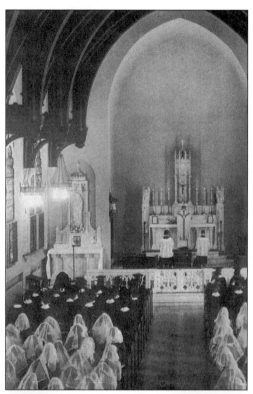

While daily 6:45 morning mass was not a requirement, attendance was reported to be high. During Advent and Lent additional special services were held. Students had the opportunity to participate in the several sacraments, including daily Holy Communion and confession twice a week. The Family Rosary was said each weekday evening after dinner in the great hall with the president of the college.

Before Vatican II, Saint Mary's students were required to wear a head covering whenever they were inside the chapel or church. Seniors wore their caps and gowns to mass on feast days and holy days. Each junior was individually presented with her cap and gown by a senior and clothed by the president and vice president of the college.

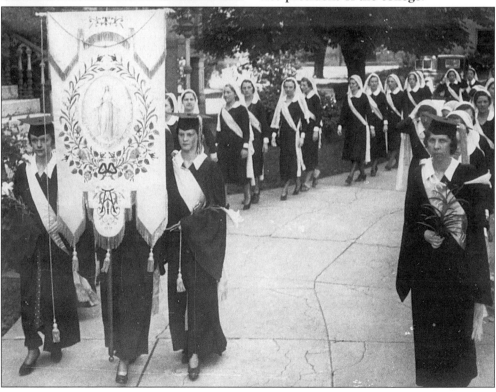

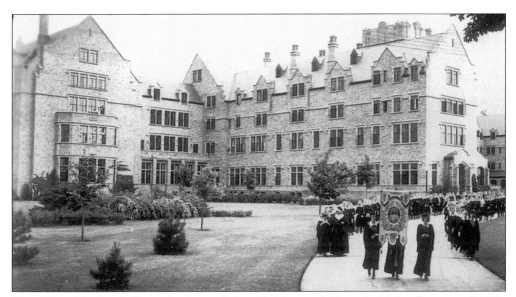

The Saint Mary's College Society of the Children of Mary held its first meeting in October of 1852. After its inception, it was charged with the care of the Chapel of Loreto as well as heading the processions for the Feast of Loreto, the Feast of Saint Mark, Corpus Christi, and the procession for the crowning of our Blessed Mother at the end of May. One of the regulations for membership to the Society was rising at 4:30 a.m. during May and singing the Litany of the Blessed Virgin in a procession to Loreto each morning. After arriving at the chapel, prayers were said, meditations made, Mass read, hymns sung, and instruction given by the chaplain.

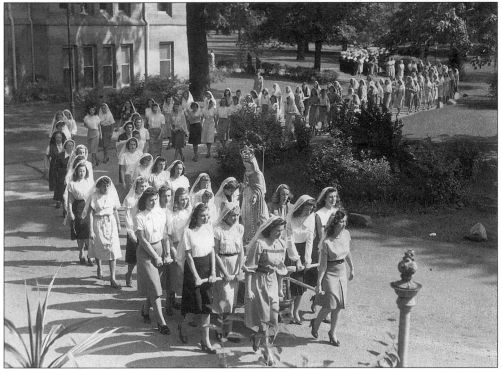

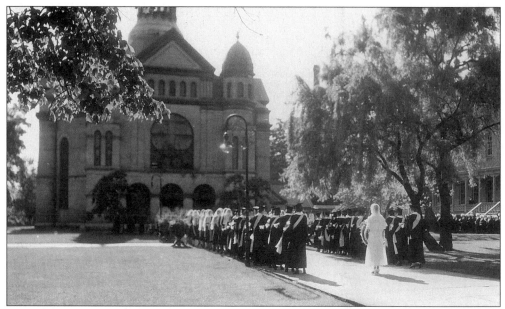

The various processions throughout the liturgical year were each sponsored by different religious organizations on campus. A short list of such organizations that existed in the 1920s is: Sewing Section of the Children of Mary, the Catholic Student's Mission Crusade, League of the Sacred Heart, the Rosary Society, the Eucharistic League, the Holy Angels Sodality, and the Sodality of Our Lady.

An example of the service aspect of religious instruction at Saint Mary's was the work done by the Student Spiritual Council in 1932. The Singer Sewing Machine Company donated electric sewing machines for the students' November sewing project for the American Red Cross. Another service project was the annual Mission Commission's red-ribbon food baskets, which were made for needy families in South Bend.

Since "to sing is to pray twice," every student attended a one-hour Sacred Music class each week to learn Gregorian chant and seasonal hymns (*Student Handbook*, 1959). For those interested in singing the Proper of the Mass, the Schola Cantorum met twice a week to practice. By the mid-1970s, and continuing to this day, the Campus Ministry department assisted students in preparing music for Sunday liturgies.

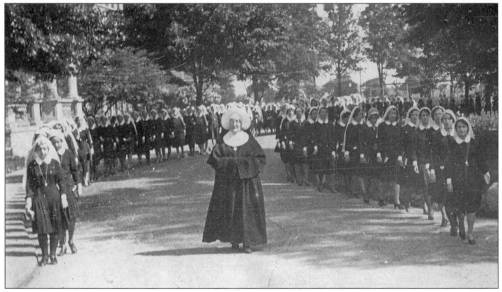

Processions like this one were seen every Sunday and on special holy days up until the 1960s. Along with the other dramatic societal changes during the 1960s, religious instruction and expression at Saint Mary's underwent change, and the processions eventually faded away. Pictured here is Sister Claudia, Prefect of Discipline, leading students to Sunday mass in 1930.

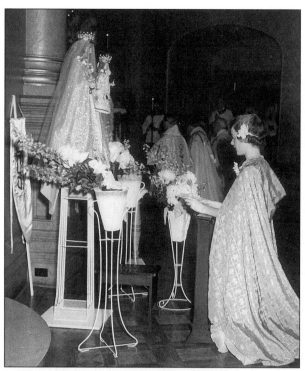

The concluding exercises for the month of May were described in the 1902 *Chimes*. ". . .[I]t was inspiring to see the long line of young and old, pupils, religious, and clergy moving under the arching trees, the air vibrant with the music of prayer as the Litany of Loreto and hymns in honor of Mary were sung."

As our Blessed Mother's month, May has special significance for Saint Mary's College. Special celebrations included processions from Le Mans to the Church of Loretto, where the Sodality May Court crowned Our Lady as Queen of May. In the Holy Year of 1950, the procession included students donning costumes and carrying national flags from over 50 countries.

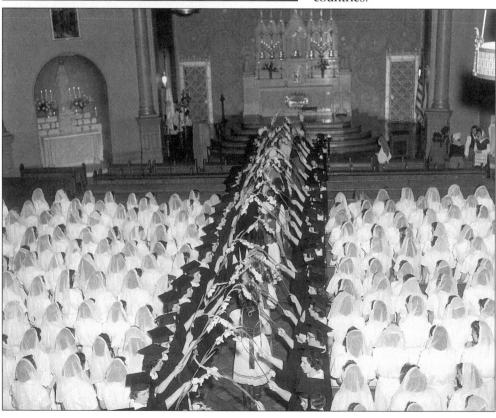

St. Michael's Chapel was the temporary home for masses and meditations when Saint Mary's Academy first moved to the Indiana campus. Bad weather wore on the small structure, and in 1869 it became unsuitable for winter use. Mother Angela dreamt of erecting a church dedicated to Our Lady where the entire Saint Mary's community could worship together. In 1886, the foundation had been laid for a Romanesque-style brick church modeled after the Santa Maria Carignan in Genoa, Italy. The sanctuary housed an altar of white marble and was decorated and lit by four French painted glass windows depicting the Annunciation, Crucifixion, Assumption, and Immaculate Conception. There were three alcoves with altars and candles for the Blessed Virgin, St. Joseph, and the Sacred Heart. The Stations of the Cross were painted by a young novitiate, Sister Liaba. Photographic arrangements like the one seen here were used in the *Chimes* around 1898–1900.

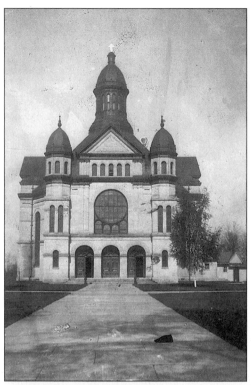

After close inspection in 1954, the original Church of Loretto was found to be unsafe. The wood from which the building was constructed had deteriorated badly. It is said that the wooden beams that supported the ceiling had become so brittle that they could be broken over your leg. The Chapel of Loreto was incorporated into the Church of Loretto when the larger structure was built.

The first gift of the Saint Mary's College Alumnae Association was in 1886. The members donated $500 for a stained glass window for the Church of Loretto, which was dedicated in 1887. One effort by the college to raise money for the church was a raffle of a handwritten document by George Washington for $1 a chance.

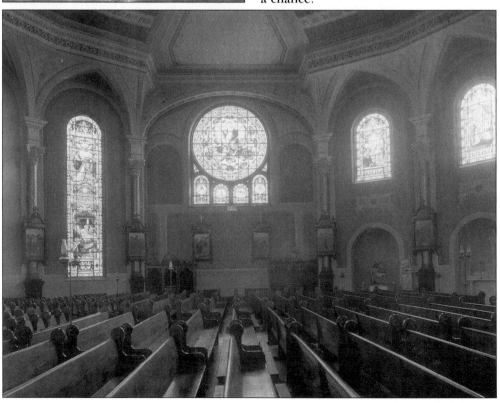

Four

THE STUDIO AND
THE STAGE

Pictured are Marie Bruhn (voice), Ada Shepherd (harp and piano), Virginia Barlow (pianist), and their teacher, Mother Elizabeth. Students benefited from instruction by both religious and lay faculty members. The first resident lay teacher on the Indiana campus was Eliza Allen Starr, who had been invited by Mother Angela in 1871. Ms. Starr had founded the first school of fine arts in Chicago before it was destroyed in the Great Fire.

Students at Saint Mary's Academy in the late 1800s were taught using European-based methods in painting and the decorative arts (artificial flowers, wax work, china painting, lace making, and leather-work). This photograph was taken in May 1886 at Trinity Arbor, which was located between Bertrand and the former Clubhouse. The 1897 *Chimes* describes why Trinity Arbor was an ideal place for artistic pursuits, "What a beautiful view of the grounds is obtained here! . . . in the month of June, roses of every variety and hue vie in sending forth sweetness. Blossoms just as fair, and perhaps fairer by contrast, are the snow-ball, peony, the trumpet-flower and the trailing petunia" The Academy building, fountain, Rosary Circle, river, and Avenue were visible from the arbor, affording a variety of scenes for landscapes, and even poetry if the girls were so inclined.

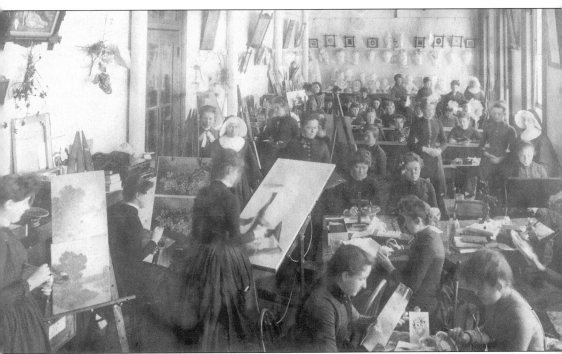

This picture, dated 1893, shows Saint Luke's art room, which was located in Academy Hall. Later, the art rooms occupied several other spaces on campus: Collegiate Hall, LeMans Hall, and finally, Moreau Hall. To coincide with the various locations for the art rooms, the student art club had numerous names: the Christian Art Society, St. Luke's Society, Saint Luke's Palette and Brush Club, St. Luke's Guild, and the Art Club. Following suit, the name of the Art Department has also altered throughout the decades. First just referred to as Fine Arts, it became the School of Design in 1867, and the School of Art in 1873. The year 1914 saw the addition of a history of art course to the curriculum, and students were first afforded the opportunity to earn a Bachelor of Fine Arts, or take "normal" courses in preparation for the teaching art in 1924.

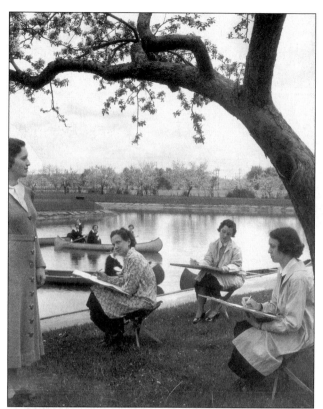

Lake Marian was not only the sight of many canoeing adventures, but it also served as an ideal outdoor studio. Here, students take advantage of the warm spring weather to practice their life drawing skills. In the 1930s, commercial art students also studied landscape drawing.

In the 1930s, Saint Mary's offered commercial art and design classes in addition to methods in art pedagogy. Studies included pen and ink, watercolors, art of posters, advertisements, shading with pencil, charcoal, and grease pencils. The large windows in the classrooms provided the necessary light.

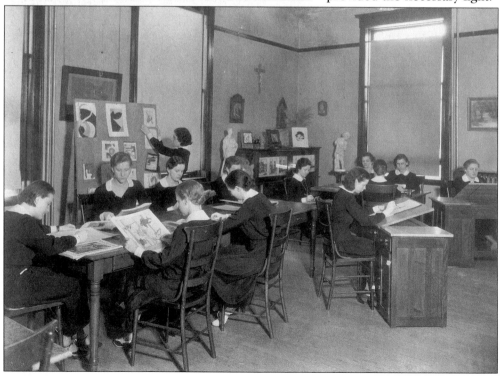

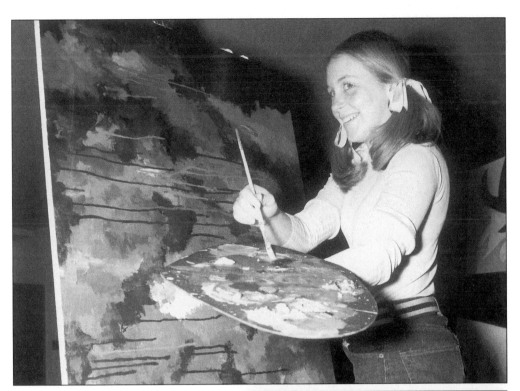

From the beginning, Saint Mary's offered training in oil painting and watercolor. In 1931, students used brush or palette and knife technique to create still life and landscape compositions. This tradition has continued, incorporating modern ideas and techniques from contemporary schools of painting.

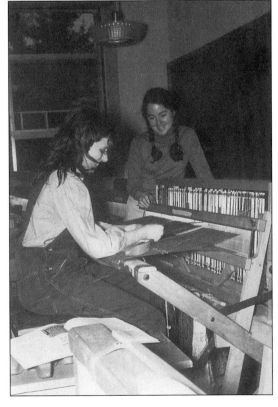

Unlike so many institutions, Saint Mary's has embraced change and sought out new ways to incorporate the best of the new with the best of the old. An example of the adaptability is the incorporation of new visual arts to the existing curriculum such as: painting, drawing, photography, fibers, pottery, sculpture, and most recently, holography.

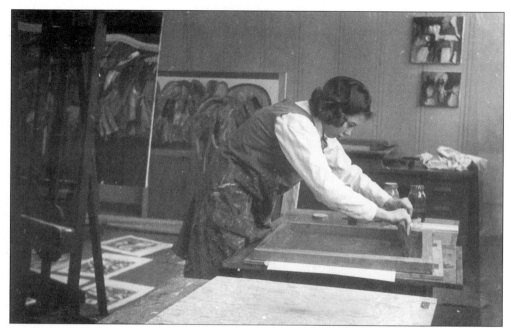

With the construction of Moreau Hall, Saint Mary's finally had space specifically designed for the arts. Not only were there ample studios for its creation, but also gallery space for its display. With this expansion of facilities came expansion of media such as silk-screening, seen here.

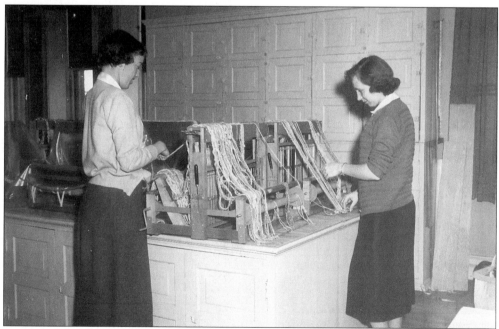

As the college grew and added more variety to its fine arts curriculum, it maintained its high quality for art instruction. As a result, in 1953, Saint Mary's was the first Catholic college in the nation to be selected for membership in the National Association of Schools for Art.

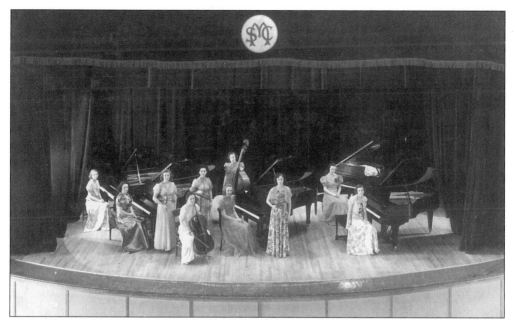

The July 1893 edition of *Chimes* stated, "The degree of excellence attained at Saint Mary's in the musical and art departments has long been recognized by the friends of the institution, and many visitors to the music halls and studios have given expression to surprise at the proficiency shown by the pupils."

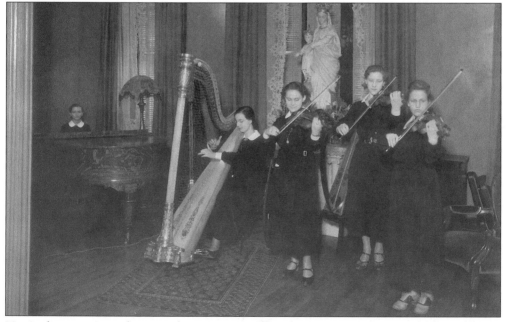

Music theory, piano, harp, and guitar were offered at Saint Mary's, even at the Bertrand campus. In 1865, the Music Hall was completed, offering 40 practice rooms and a vocal recital hall. The music department expanded into a Conservatory of Music in 1871–1872, and in 1872–1873 there were two vocal music teachers and eight instrumental music instructors for the 193 music students enrolled.

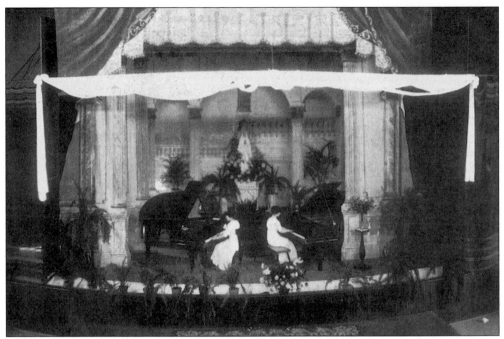

In June, the Conservatory of Music displayed the artistic ability of its musicians during Graduates' Night performances in Assembly Hall. Instrumental and vocal selections were often complemented by recitations of poetry. Reviews of many of these exhibitions were reported in national publications, and in June of 1880 the *Catholic Review* reported, "I doubt very much if a more successful musical conservatory exists in the country."

Original compositions by students in the harmony class were published in the 1902 *Saint Mary's Hymnal*. Mother Pauline mentioned the offerings of the music department in the 56th college catalog: theory and practice of organ, violin, and harp. In November of 1916, the *Chimes* listed piano, pipe organ, harp, violin, guitar, mandolin, banjo, and vocal training.

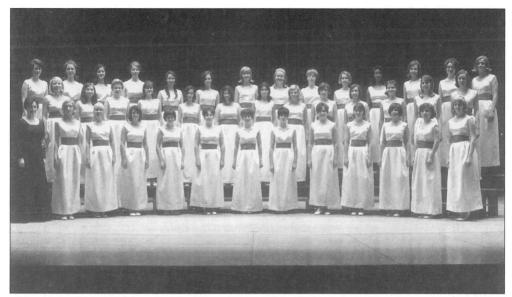

The Glee Club, as it was originally called, broadcast over South Bend's new radio station, WSBT, in 1934. That same year, the Glee Club and the a cappella choir broadcast nationally over C.B.S. In November of 1999, the Saint Mary's Women's Choir performed at Carnegie Hall when the current director, Nancy Menk, was honored for her contribution to this field.

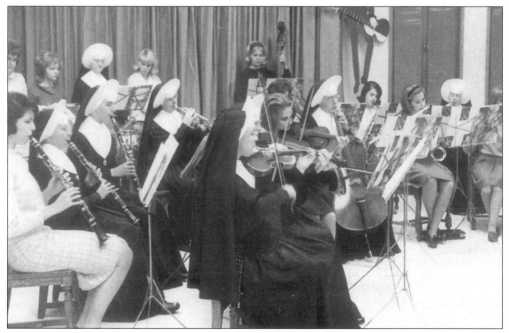

Quintets, quartets, trios, duets, and solos were the common showcases of musical talent for the Conservatory of Music in its early years. It was not until 1904–1905 that an orchestra consisting of violin, viola, cello, harp, and piano was formed at Saint Mary's. Later, a lay-religious orchestra was able to bring students and sisters together through music.

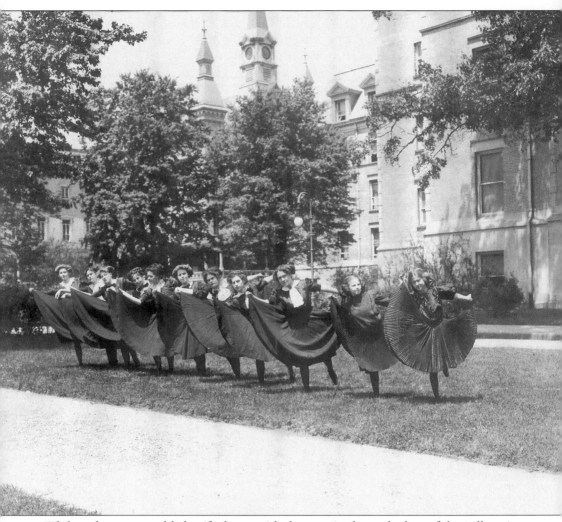

While today one would classify dance with the arts, in the early days of the college it was listed with the physical culture courses. When this picture was taken at the turn of the century, dance was referred to as "free movement," and later, in 1957, modern dance was officially added to the athletics department. *Chimes* from that same year takes up the argument for dance as art, "Modern dance particularly is in the category of dislikes often because its 'critics' do not understand it. Nevertheless, it is entitled to retain its place among the fine arts as a valid form of expression and communication The tempo of America is fast: we like our cars and airplanes and houses streamlined; we want our functional surroundings with no excess decoration The same tendency is true in contemporary dancing."

Annual St. Patrick's Day celebrations were not merely social functions—they incorporated the fine arts as well. In 1901, the freshman class performed, "Come Back to Erin," in Saint Angela's Hall. The evening began with the portrayal of ancient druid ceremonies. Next, an excerpt from a story, a scene, and a tableau depicted the coming of Christianity to Ireland. In between dramatic scenes depicting the history of the saints and scholars of Ireland, students performed beautiful dances to melodic musical interludes. The domestic science classes frequently contributed their skills for performances such as these by sewing the fine costumes that added a much-appreciated element of realism to this fantasy play. These freshman players were photographed in full costume outside Saint Angela's Hall.

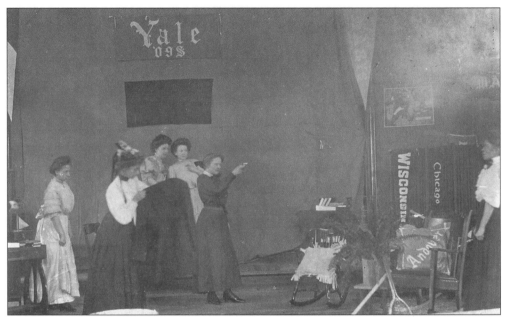

A quick glance at the Saint Mary's *Chimes* from the early part of the century would indicate to even the most casual observer that performance art, specifically drama, was an important and ever-present part of the campus. Pictured here are members of the classes of 1910 and 1911, performing in Saint Angela's Hall.

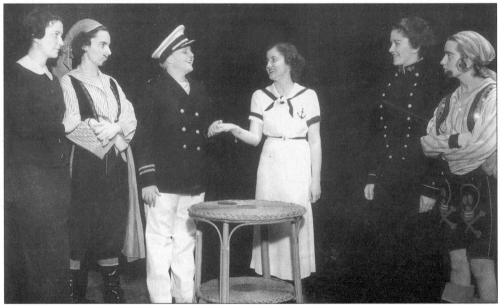

Saint Mary's theatrical productions were not developed merely for their entertainment value, but also for their educational merit. Rhetoric and elocution were a part of the curriculum from the 1860s, and were later followed by courses in reading and voice culture in 1911, expression in 1919, and the opening of the speech department in 1936. A minor in drama existed in 1962, and in 1966–1967, Saint Mary's and Notre Dame combined their drama courses and theater productions.

Five

GYMNASIUM ECHOES AND FIELD DAYS

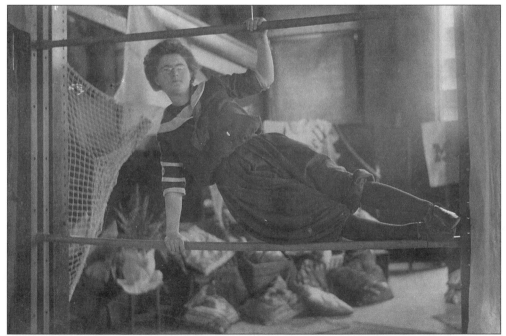

The enjoyment of the physical culture course was an important consideration for its inclusion in the program of study at the college, but far more important were its benefits to the students. It was seen as a preventative to the students "being completely worn out at the close of the school year" from the pressures of studying and the confinement of the winter months.

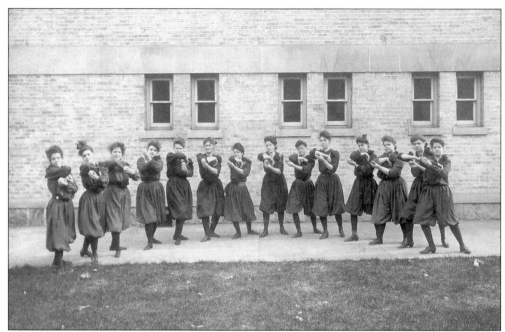

Julia Cochrane, who graduated from the Boston Normal School of Gymnastics, was the first physical culture instructor. According to the January 1900 edition of *Chimes*, she educated the women using the Swedish system, "which comprises exercises of free hand gymnastics, exercises with light and heavy apparatus, as well as jumping, breathing, and running movements, combined with marching."

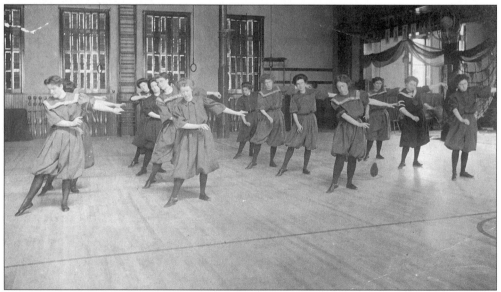

Placement testing at the beginning of the term indicated to which physical culture classes each student was assigned. Beginners were instructed in free movements that stretched the muscles, loosened the joints, and "set up the figure." The purpose of these classes was to promote "ease and grace of motion as well as alertness and accuracy" (*Chimes*, 1902).

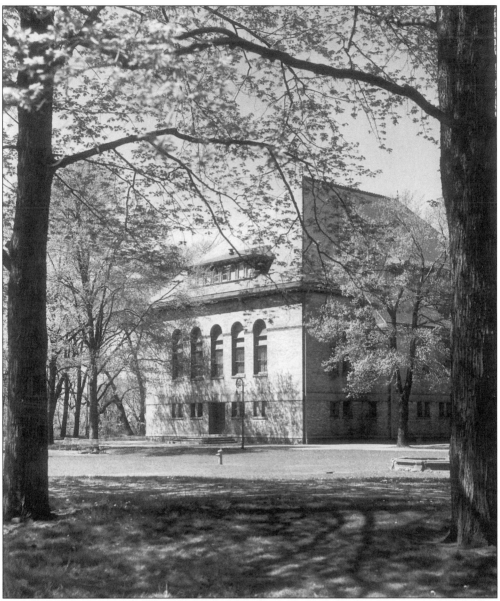

Dedicated in May of 1892, Saint Angela's Hall served as the campus gymnasium for sporting and social events. Despite the gradually sloping floor, it was well suited for athletics because of its lighting and ventilation. Students participated in physical culture courses that included such sports as fencing, basketball, calisthenics, athletic dancing, dumbbells, and light apparatus work. The hall was demolished in 1975 before a new athletic facility had been built, leaving indoor sports out in the cold. Activities that did not require a lot of space or movement were squeezed into existing recreational areas. Basketball became a traveling team, as practices were held at schools or health clubs throughout South Bend. An agreement was reached between Logan Center and the players—basketball lessons for the center's residents in exchange for one-and-a-half hours of gym time each week. Two years later, Angela Athletic Facility was built to accommodate the varsity teams, intra-mural sports, clubs, and recreational activities available on campus.

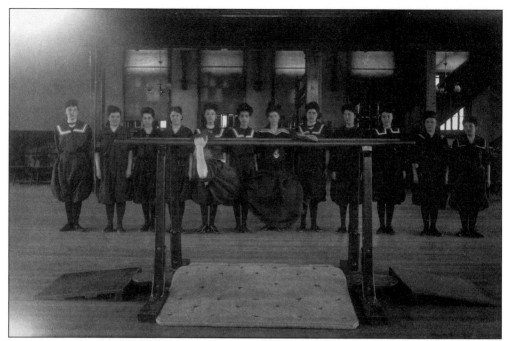

Pictured here is an example of heavy apparatus, the parallel bars. Others included: traveling rings, vaulting horse, Swedish boom, swinging, and climbing rope ladders. "There were those who considered this move much too 'advanced' for young ladies, especially for they could be seen in bloomers, climbing about on this strange apparatus newly installed" (*Family Portraits*, p. 40).

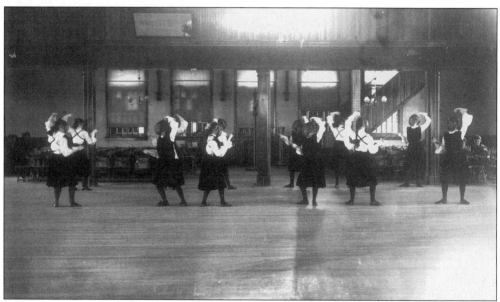

Fencing creates "faculty and grace of muscular movements, quick perception, and power of control, comes nearer to the manly sports than any other line of work, and yet a girl never loses the beautiful self control so essential to the woman-kind, while it brings every muscle into play" (*Chimes*, 1901).

"The exercise with the bow and arrow is especially fine for the girls, for it not only, as with the foils, teaches them quickness of sight, but it adds grace to the standing position and elasticity to the walk" (*Chimes,* 1901). In 1911, *Chimes* reported that while archery was not common at most schools, Saint Mary's had a regular following and held an end-of-the-year tournament.

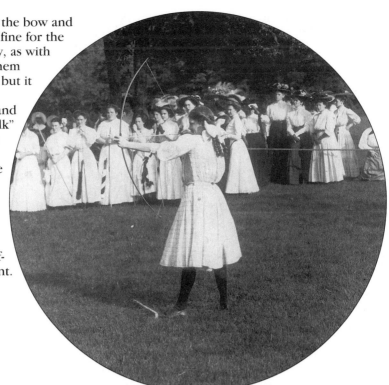

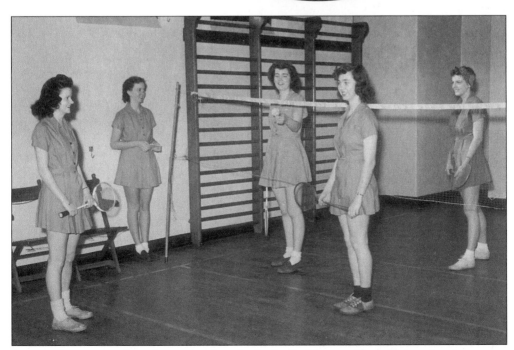

Among the sports offered were hockey, basketball, riding, volleyball, tennis, ping-pong, hiking, fencing, golf, track, badminton, skating, and archery. The goal of all of these activities was to promote good sportsmanship and fellowship among the students.

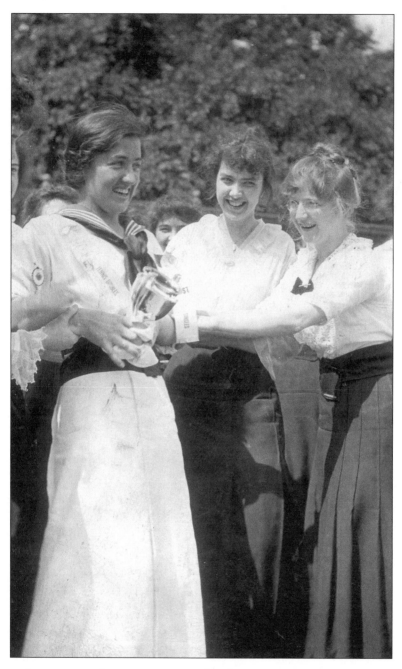

The *Chimes* and *Academic Annuals* of this era regularly included prose and poetry about the various sporting activities at Saint Mary's. The finishing school stereotype of fragile young woman passively spending their time on impractical crafts cannot stand up to the reality of Saint Mary's, where student-athletes participated in fierce sporting competitions and then wrote poems about them in grammatically correct English for their student publications.

In autumn when we come to school,
The days are calm and mellow—
Delightful for long walks and jaunts,
Amid the gold and yellow.
In winter, skating holds full sway,
While snow and ice are reigning—
All cheeks are rosy, eyes are bright,
And mirth hears no complaining.

In springtime come the happy hours
When each one loves her neighbor—
Canoeing, tennis have their day—
Now, where's the time for labor?

By Claudia Redmond, Third Academic, in 1915.

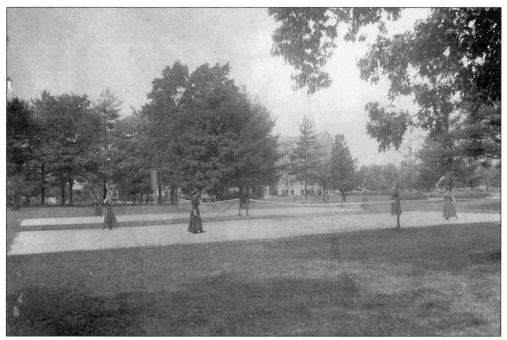

Tennis has been seen on campus since the turn of the century. In 1924, there was such a demand for court time, the Tennis Club had to limit singles play to one hour and gave priority to students who needed to practice for tournaments. That same year, Mr. Frank Mayr of South Bend donated a new trophy for the three-year cup of tennis singles.

In this turn-of-the-century photo, the students participated in one of their favorite sports. It was not until 1915 that Saint Mary's installed its first concrete tennis courts. The winner of the tennis champion in singles received a trophy cup, and the champions in doubles received tennis rackets.

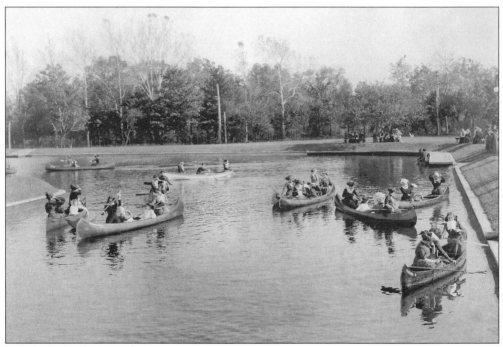

In 1906, under the direction of Mother Pauline, an apple orchard was felled so that Lake Marian could be excavated. Lake Marian was to have a concrete foundation and fine landscaping. The original contractors quit, siting the job was too difficult. Mother Pauline found a replacement, and the lake was completed by May 1907. Mother Pauline oversaw the details of the construction while maintaining her spiritual and cultural duties to the school.

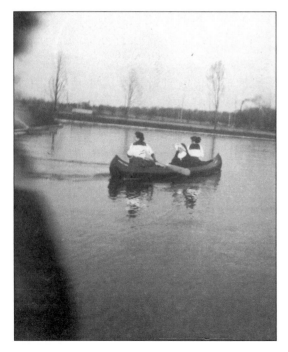

On May 2, 1907, Lake Marian was dedicated with blessings, hymns, and the traditional bottle of champagne broken over the bows of the three boats, *Marie L.*, *Pleiades*, and *Marathon*. While the boathouse had not yet been erected, funds had been donated and the boathouse was built in time to be photographed and shown in the November 1907 *Chimes*. The first Boat Club dance was held in February 1909.

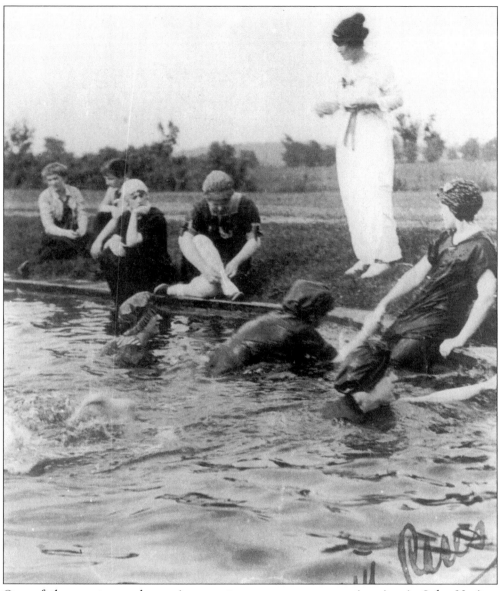

One of the most popular spring sports on campus was swimming in Lake Marian, referred to as bathing in the 1924 *Academic Annual*. For the swimming races that were held that year, there were several prizes awarded. The first-prize winner from the College won a silver bracelet. The first-prize winner from the Academics (high school) received silver slipper buckles. Second-prize winners from both sections earned gold corsage pins. Swimmers who attended Saint Mary's in both 1906 and 1907 must have been overjoyed at the improvement in aquatic facilities between those two years. From 1850, when a bathing house was being constructed on the Bertrand campus, until 1907 when Lake Marian was first filled, the St. Joseph River was the scene of all watery recreation. By the 1920s, however, students had forgotten their good fortune and were clamoring for an indoor pool. Twenty-seven years of river swimming seems short compared to the 53-year wait students had to endure until Vincent Barko donated funds for the pool in Regina Hall in 1973.

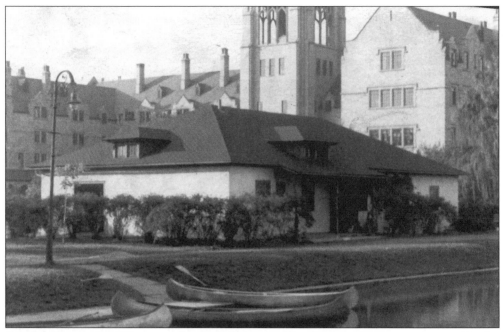

Lake Marian was used for canoeing, swimming, and ice-skating. Canoes were stored in the boathouse after it was completed in late 1907. Class competitions in canoeing were held in the spring with the champions earning paddles. The 1912 *Chimes* states that, "Patches of sunburn and blistered hands are evident proofs of the canoe activity on Lake Marian."

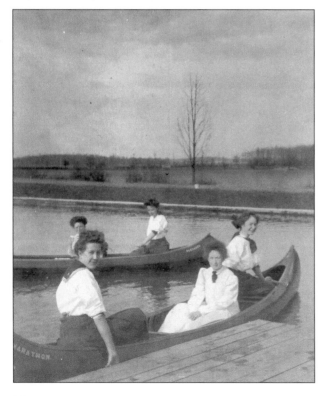

Canoeing provided relaxation, "Keep up this good spirit, recreation time is for recreation, not study. The sane out-door girl is likewise the good student" (*Chimes*, 1912). The 150 young women who were members of the Saint Mary's Canoe Club in 1912 were both. The club examination covered: parts of the boat, proper stroking technique, and piloting. Students who passed the exam had the coveted honor of wearing the canoe pin.

There were several requirements that students had to meet in order to be eligible for the team and merit awards. The student needed to have passing grades in all classes, undergo a thorough medical examination, and pay their athletic fees. The fees paid by each of the students greatly helped to offset the costs of the letters, numerals, upkeep of the gymnasium and tennis courts, as well as the purchasing of new equipment.

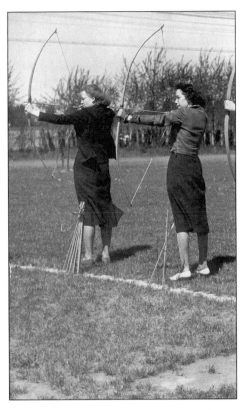

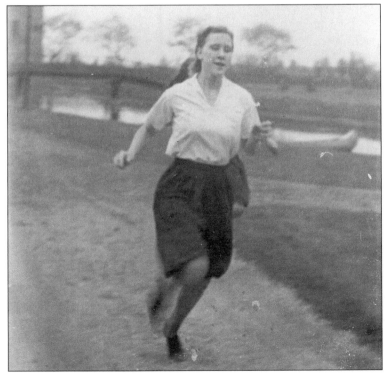

Each of the girls not only strove for the pride of their class, but also for the most points in order to achieve their letters. The letters were of white felt on a blue background. The champion in each sport was awarded a letter. In addition, numerals of white were given to the runner-up and points to each student that participated in the event.

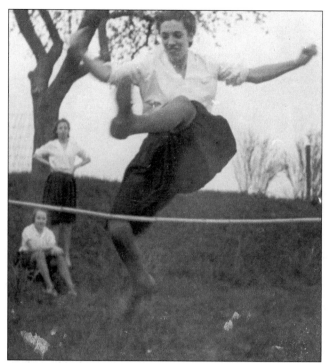

The girls of track and field competed in class competitions during Sports Day. The events included running, jumping, hurdling, and throwing the basketball. Minims, the elementary students, and juniors also took part in their own annual Field Day Exercises, though the events and prizes differed slightly; dumb bell drill, relay, potato sack and three-legged races, tennis, and ball throwing, with winners receiving boxes of candy.

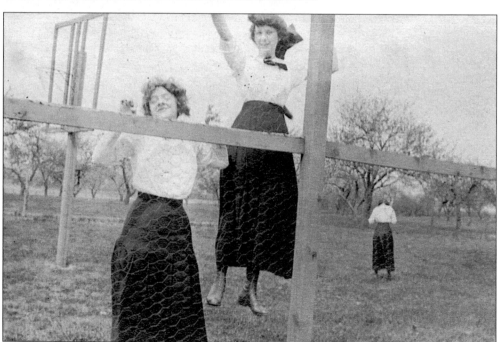

Indoor games gave way to outdoor fun. "The first warm days in spring the gymnasium is decidedly deserted, but following the sound of voices you find the work has only been transferred from the gymnasium to the campus" (*Chimes*, 1901). "And now is the roller-skating season/Coming spring must be the reason" (*Academic Annual*, 1922). "Jumping rope, a familiar scene—a sure sign of spring" (*Chimes*, 1912).

*"Hail to the team that in
triumph advances,
Honored and praised be
the old basketball,
Long may our score,
which before our eye
dances,
Stay on the blackboard
in St. Angela's Hall!
Heaven send no defeat!
Oh, defend us, let us
beat!
And our team will fight
and fight;
while every student's den
Sends back our cheer
again,
Blue and White! Blue
and White!"*

—By Marguerite Kelly

(*Academic Annual,*
1924.)

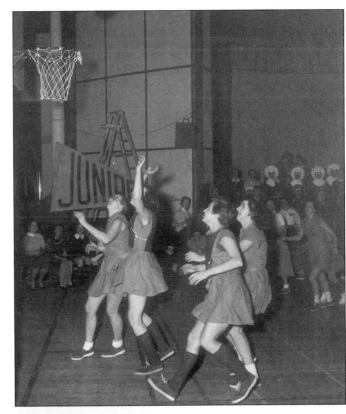

Corsets and long skirts did not prevent Saint Mary's students from taking part in Hoosier Hysteria (basketball fever). From as early as 1900, classes competed against one another in fast-paced basketball match-ups. The results were reported in *Chimes* and later in *The Static*, the college newspaper which began in 1926.

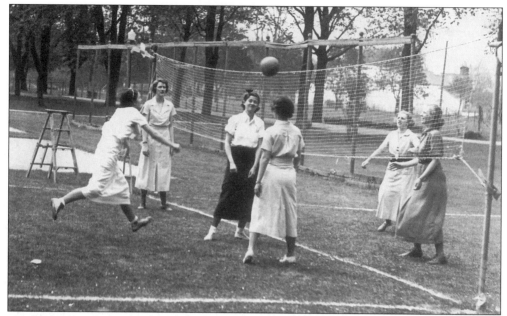

The Women's Athletic Association was one of the largest and most active organizations at Saint Mary's. This club offered every girl the opportunity to participate in sports programs throughout the year. In order to join the W.A.A., a student was required to participate in at least one major sport during the year.

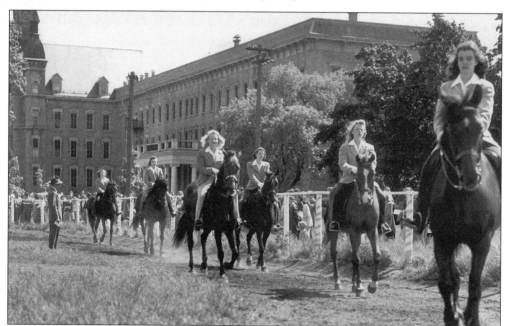

In 1870, Mexican ponies were brought to campus for the students to ride, thus began the annual horse show. By the 1950s, it was sponsored by the Women's Athletic Association and had been expanded to include drill teams. The Saddle Club, which met on Wednesdays and Saturdays, and required at least three hours of riding a month, allowed the students to develop their horsemanship.

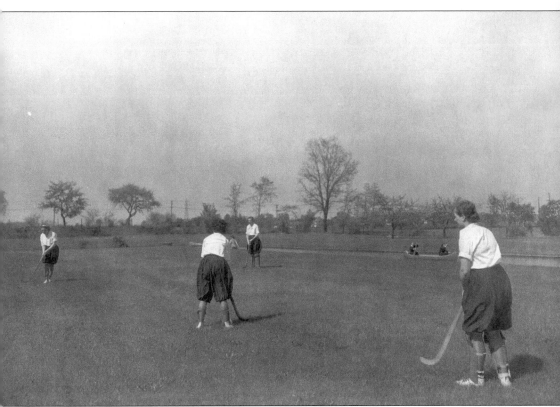

The first intercollegiate competition for Saint Mary's was in field hockey. In November of 1932, a team of 12 students, accompanied by the athletic director and general manager of hockey, traveled to Chicago to participate in the "Play Day" for college and university students. During their visit they won against Lake Forest, tied with University of Chicago, and lost to Battle Creek College. This early competition between schools was ahead of its time, because it was not until 1971 that the first national governing body for women's athletics, the Association for Intercollegiate Athletics for Women, was formed. Soon after its formation, Saint Mary's College had nine varsity teams. Today, Saint Mary's is a member of both the National Collegiate Athletic Association (Division III) and the Michigan Intercollegiate Athletic Association, and has eight varsity teams: basketball, softball, swimming, tennis, volleyball, soccer, indoor and outdoor track, and cross country.

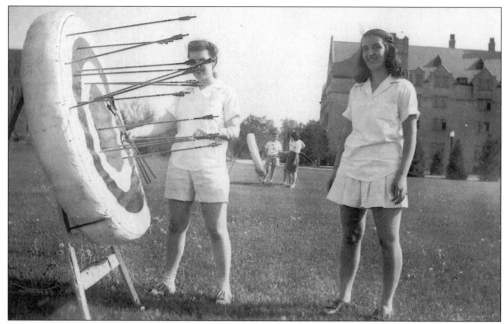

The educational value of sports was highlighted in the January 1923 issue of *Chimes.* "The training and discipline gained from participation in organized sports of any kind will serve in the effort to acquire knowledge in the classroom. Discipline, teamwork, and loyalty are lessons everyone needs to learn." The development of true sportsmanship was emphasized over the development of skill.

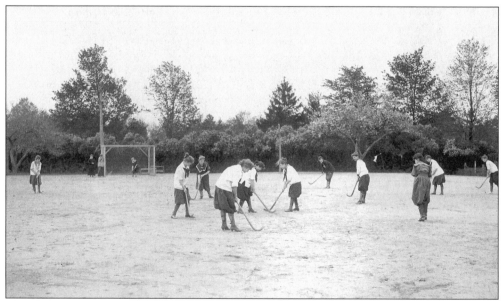

The physical education program was always an integral part of the Saint Mary's experience, and in 1925, the administration set down six reasons for its continuation: 1) to alleviate mental strain; 2) to encourage good posture and correct carriage; 3) to develop grace and skill; 4) to maintain good health; 5) to develop strength and vigor; and 6) to strengthen willpower, alertness, reaction, self control, self denial, and loyalty to classmates.

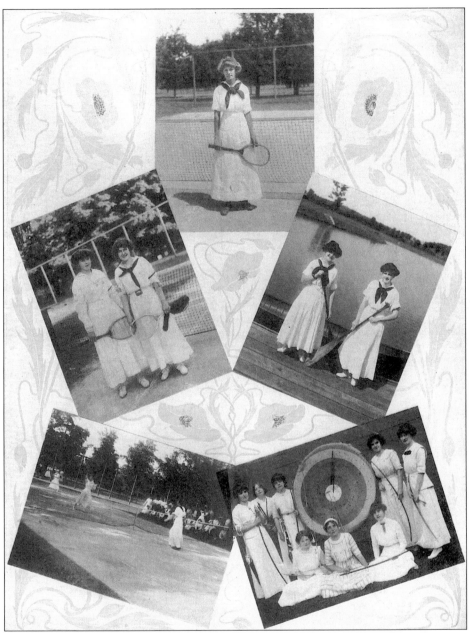

The 1912 *Chimes*, where this picture was first published, remarks, "Saint Mary's girls never engage in contests with other schools, but plenty of rivalry is engendered between the different departments of the institution. The rivalry between the Academic and Collegiate Departments was especially keen this year, and in every contest the college girls went down to defeat at the hands of their younger but determined rivals. Not all of St. Mary's girls have the outdoor spirit, but those who have are apt to be interested in all, or nearly all, forms of sport provided by the faculty. Often the same girl wins distinction in two or three different games. That their other work does not suffer is evident in the fact that more than one valedictorian has won distinction in the tournaments." From 1907 to 1912, the outdoor sports program had grown to over two hundred participants.

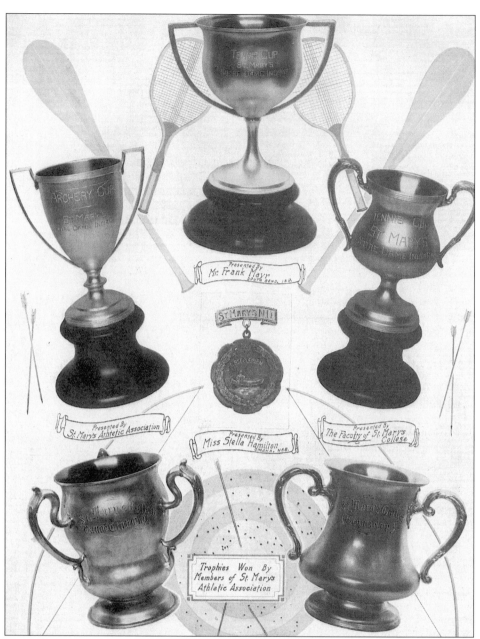

Collected here are the various trophies participants could earn during spring competitions in 1912. The silver canoe cup, seen in the lower left, was 2 feet tall. There were two recipients of the cup since it was awarded to the winners of the doubles race. *Chimes* reports their solution to this dilemma, "Each young woman will keep the trophy at her home one year. At the end of two years, they will have the cup cut in halves, and the parts mounted, each one taking a part." Also shown are the paddles that were also given to doubles winners, and the tennis rackets that were awarded to tennis doubles champions. Stella Hamilton, class of 1892, who later donated funds for LeMans Hall, offered gold medals to winners in the tennis and canoe singles, as well as archery. Several of the cups seen above are housed in the Saint Mary's archives.

Six

EVERYDAY SCENES

In the 1915 *Academic Annual*, Saint Mary's was said to have "earned the reputation of being one of the most thoroughly equipped and successful educational institutions in the United States. The Academy buildings are beautifully located on an eminence overlooking the picturesque banks of the St. Joseph River, the highest and healthiest part of the State."

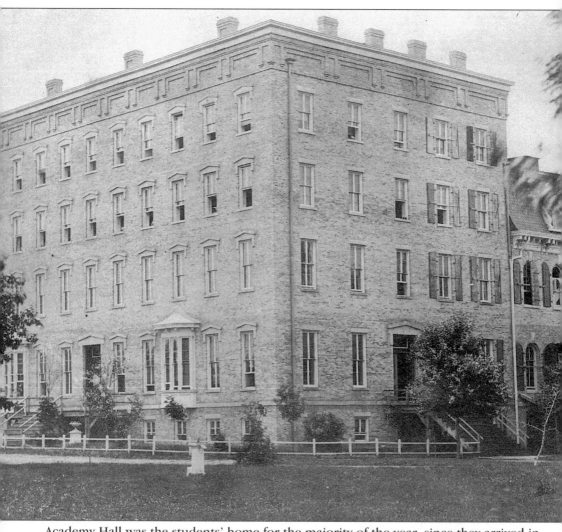

Academy Hall was the students' home for the majority of the year, since they arrived in early September and were released for summer holidays after commencement in June. Prior to the 1920s, they were only given five vacation days at Christmas, so most stayed on campus. The sisters knew that since the students spent the majority of their time on campus, their home-away-from-home needed to be aesthetically pleasing. To that end, they made continual improvements to the hall throughout its 40 years as the main college building. Ceiling moldings, walnut banisters, and etched glass on the front doors all welcomed the girls and made Academy Hall feel more like a home than an institution. Surrounding the building, landscaped gardens provided picturesque scenes from the many windows of the four-storied structure.

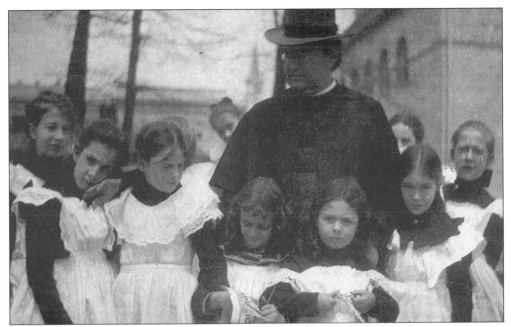

Minims were accepted from 1844 until 1949. Marian McCandless, class of 1901, photographed this group of Minims in their uniforms with Father Haggerty. It was not until 1854 that Notre Dame accepted young pupils. The instruction of these boys was entrusted to the Sisters of the Holy Cross in 1863.

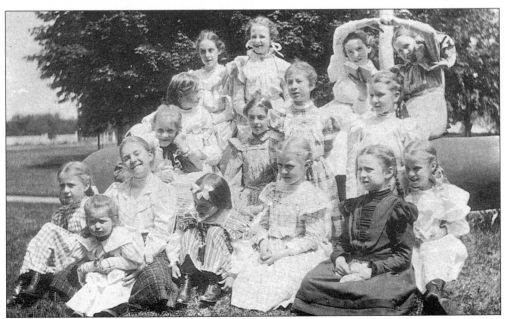

The students at the Academy were divided based on age. Girls under the age of 12 were placed in the Minim Department, while those between the ages of 12 and 15 were placed in the Junior Department. Each division had its own study hall, playgrounds, and sleeping apartments. Minims also enjoyed their own spring sports day, academic competitions, and premiums (which were academic achievement awards).

Lourdes Hall was built as an all-purpose building in 1871–1872. Mother Augusta designed the building after the Overton Hotel in Memphis, Tennessee, where she served as a nurse in the military hospital during the Civil War. Lourdes Hall was a northern addition to the Music Hall, and later connected to the Tower Building. It contained Assembly Hall, the first space dedicated solely to performances and convocations. It is uncertain where these types of assemblies were held before. Saint Rita's Dormitory, seen above, was also a part of Lourdes and housed the Minims, students under the age of 12 who attended Saint Mary's Academy. It is little wonder that as Saint Mary's grew, more student housing had to be added since all students were required to live on campus. Day students were eventually permitted in 1939.

Saint Joseph's Hall was constructed in 1901, and was the first addition to the campus under Mother Angela's administration. The building housed a dispensary, 18 bedrooms, 2 day rooms, a reception room, and a laundry room in the basement. At the time it was built, much emphasis was placed on well-ventilated buildings and the overall health of the students in the College's publications.

Originally called Collegiate Hall, Holy Cross Hall was dedicated in 1903 and housed both the Colleges and the Academy. Collegiate Hall was used for all student and faculty functions—dining, library, infirmary, offices, study hall, and classrooms. The close proximity of the student residences to the laboratories became a concern in 1953, after a chemical fire threatened to damage other parts of the building.

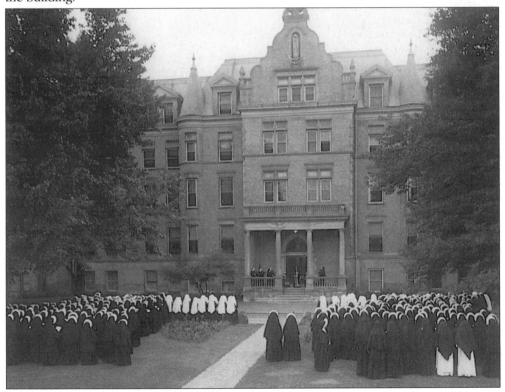

The seniors of the college purchased their own furnishings for their rooms, and alumnae provided the furniture and decorations for the parlors when Collegiate Hall opened in 1903. When the graduating class of 1904 departed, they generously donated their furnishing to the college. While the rooms were modestly decorated, the students personalized them with souvenirs, programs from plays, pennants, photographs,

drawings, and other memoirs of the events during the year. By 1959, the school provided each room with a desk, chair, chest of drawers, and bed. The girls were encouraged to add their own "final touch of something green and growing, a favorite crucifix, Madonna, or statue."

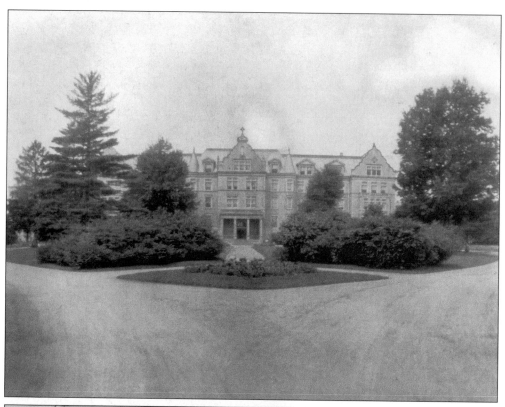

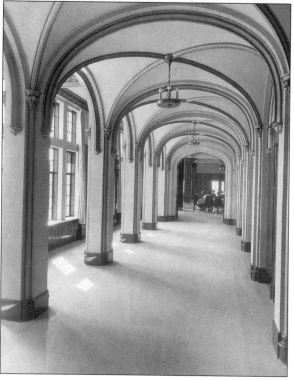

Although the actual layout of the campus differs from the early visions of the founders, the dramatic effect of the Avenue has not been lost. Originally, the Avenue led directly to the front of the Tower Building. With the placement of Collegiate Hall directly in front of the tower, the Avenue was changed to form a circle.

LeMans Hall, built in the Tudor Gothic style, has a 392-foot frontage. At its opening, some of the highlights of the building included the Louis XIV Ballroom, Stapleton Lounge, two elevators, fire-proof stairways, and "soundless rubber floors." It was named after the town in France where Abbe Moreau founded the Congregation of the Holy Cross. Pictured here is the corridor that connects the main entrance with the dining room.

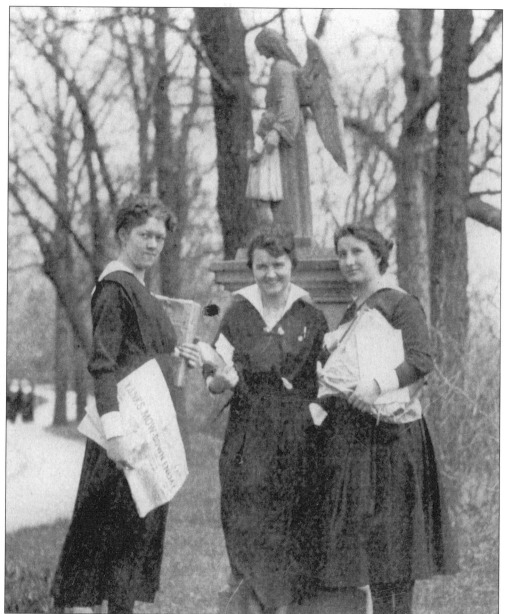

This photograph from 1918 shows the prescribed uniform that students were required to wear. Only on two or three occasions throughout the year were the students allowed to deviate from their school day or Sunday uniforms. In 1898, everyone wore navy blue for regular school days, but each department had its own specifications for the Sunday uniform. In winter, seniors wore black wool while juniors and minims wore red. In summer, the Sunday uniform color code was the same, but skirts were permitted instead of the woolen dresses. Tailored outfits, patterned materials, and silk linings were not allowed. As long as the color of the material matched the sample sent to parents, the style of the Sunday dress was not designated. The students were given sewing time during which they maintained their uniforms under the direction of an instructor. The uniform was eliminated in 1962.

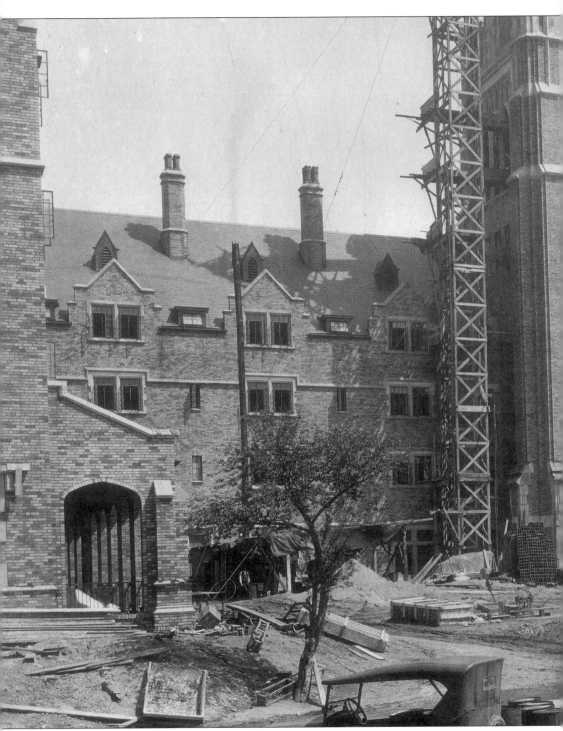

LeMans Hall was built in 1925 and was referred to by students and faculty as the "new campus." The building had a dining room, promenade, cloistered walks, post office, four drawing rooms, four reception rooms, a study hall, the library, the infirmary, and a sun porch attached to the lounge. At this time, only the third and fourth floors were

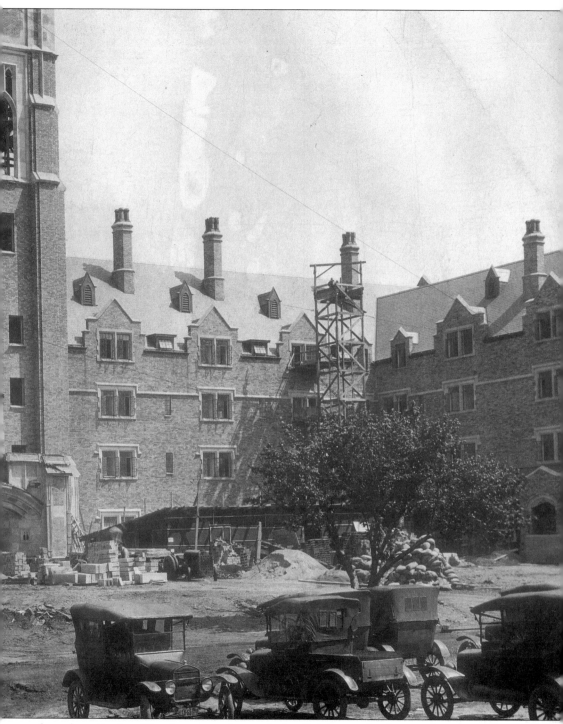

used as dormitories. The basement housed the Oriole candy shop, a beauty parlor, trunk room, Rectangle recreation area, as well as a laundry and pressing room. Upon completion, LeMans Hall housed the college students, while Collegiate Hall became the dormitory for the Academy.

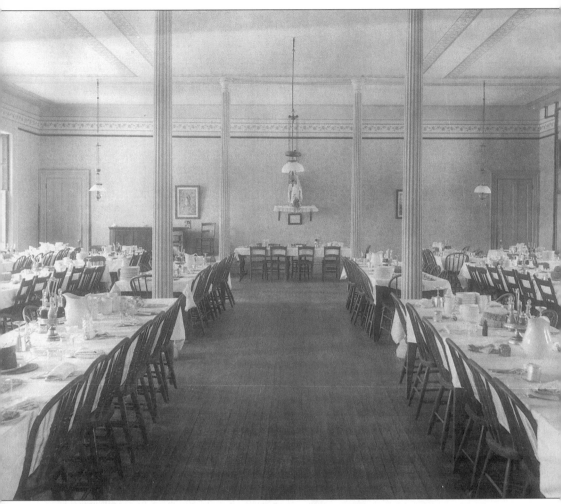

This photograph of the Lourdes Hall Refectory was taken in 1893. Students were required to supply "two knives and forks, one large and one small silver spoon, 12 napkins and a glass or silver cup" for their place setting. "To this department, three times a day, do the light-hearted, hungry girls repair, where full justice is done the abundant, carefully prepared and neatly served viands"(*Chimes,* 1893). In 1894, a major technological improvement was added to the Refectory—gas fixtures for lighting. The Academy and the College shared the same dining space until LeMans Hall was built in 1923. The most recent dining facility, the Noble Family Dining Hall, was built in 1965 and seats one thousand. While students in the early years had to supply their own place settings, in recent years they have helped themselves to place settings from the dining hall. A sure sign of the end of the school year is the return box in the lobby for "borrowed" cutlery, dishes, and cups.

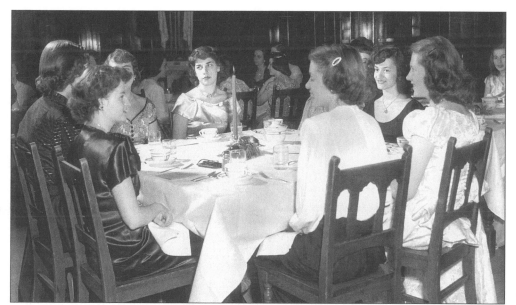

Students ate in a family style setting and were assigned to a different table every six weeks. Monday through Thursday at both lunch and dinner, the girls had to sit at their assigned table, with one student or sister acting as the hostess. Everyone stood at their place at the beginning and end of each meal while grace was said.

Besides the library and their dormitory rooms, students had the advantage of using their class study halls. These spaces allowed for individual and group study and encouraged the development of class unity and loyalty, which showed itself most fervently during interclass academic and sporting competitions. The ribbons and trophies won in these competitions softened the formality of the rooms.

This sweet pastoral scene is set on the Saint Mary's dairy farm from which the campus derived its milk, butter, and a large part of its meat. Twelve to twenty cows were slaughtered each week to "feed the hungry ones at St. Mary's." In 1924, 120 of the 250 gallons of milk produced daily were used for drinking and domestic purposes. Although much of the dairy was state-of-the-art, six farm hands still milked each of the 72 cows by hand, and curie combed them every day. The kind treatment of the cows made them "as meek as the old family bossy." Since 1914, the cattle were tested for tuberculosis every six months, and always passed, just as one would expect from the descendants of the famous ten cows that won the butter-fat contest in Lafayette, Indiana. (*Academic Annual*, 1924)

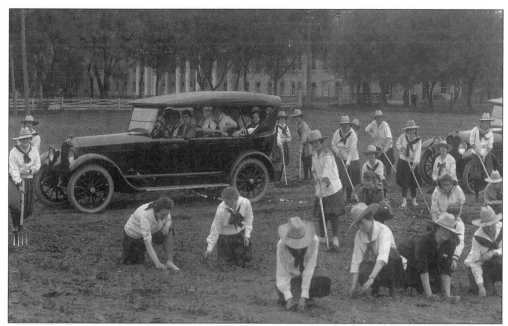

Besides the required course work, one of the expectations for being part of the Saint Mary's community was helping on the farm. Not only was this an educational and social experience, but the farm also provided the school with most of its food. This photograph was taken in the 1920s, and Augusta Hall can be seen in the background.

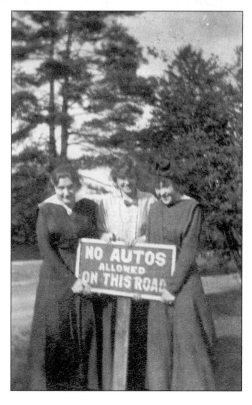

Motorized transportation has caused mixed reactions at Saint Mary's over the years. In the 1910 *Chimes*, the students predicted that, "before long . . . the automobile will be the sole means of conveyance." In March of 1911, however, *Chimes* reported that, "the speed limit certainly has not been exceeded at St. Mary's for, though the artistic garage stands unfinished, alas! it is without an occupant."

As late as 1959, students were not allowed to keep cars at school or in town, except for seniors who could receive special permission from the Dean of Women during the last week of school. Students who received permission to leave campus for a trip into town took either a carriage, the streetcar, or later, the bus. Sheekey's Bus was a horse-drawn vehicle that carried students between South Bend, Notre Dame, and Saint Mary's in the 1870s. It also connected with trains on a regular basis. The railroad that connected South Bend with Chicago was not constructed until 1851. Prior to the train, students traveled from Chicago by steamboat across Lake Michigan, and then by stagecoach to campus. With the completion of the railways, both Saint Mary's and Notre Dame saw a significant rise in enrollment.

Seven
THROUGHOUT THE YEAR

A quick, glad word of welcome,
A warm, responsive smile,
A feeling of home coming
After many a weary mile,
Ah, they fill my heart with longing,—
Sweetest loneliness,
All reminding me of loved ones,
I pray God e'er to bless.
From the poem, "Alma Mater," by Maguerite McEnerny, 1915.

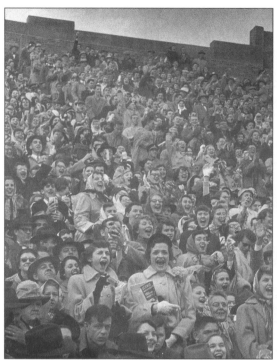

It was not until 1919 that cheers for the Fighting Irish included the voices of students from Saint Mary's. Football culture soon became a standard feature of the Saint Mary's social scene as we see in this 1922 excerpt of the *Academic Annual*, "And now at last the home coming game./ Good luck to you, Old Notre Dame."

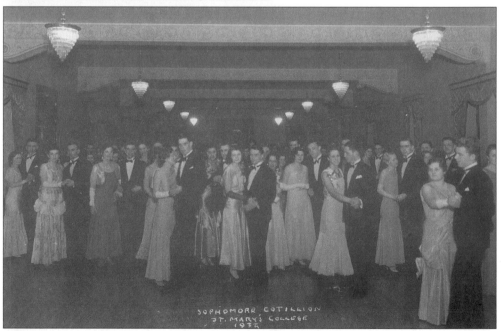

There were many occasions for formal celebrations at Saint Mary's College, as well as many places to celebrate. Classes and clubs throughout the school year sponsored the Inaugural Ball, WAA Formal, Charity Ball, Sophomore Cotillion, Junior Promenade, Freshman Formal, Sodality Dance, Spring Formal, and the Senior Ball. Dances were held in the dining hall, Pine Grove Club House, Louis XIV Ballroom, the Speech Studio, and the Canoe Club House.

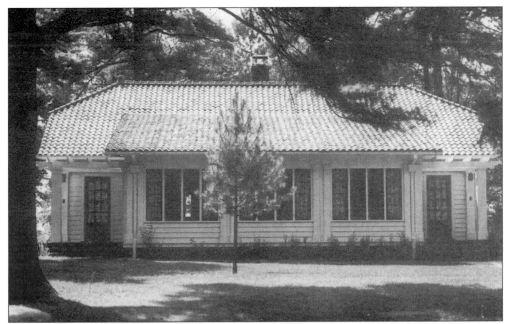

The Pine Grove Club House was made possible by "the initiative and resourcefulness of the senior class of 1923" (*Panorama*, p. 66). As a show of appreciation for the generosity of the businesses and residents of the city who donated funds for the building, the seniors threw a celebration for the people of South Bend.

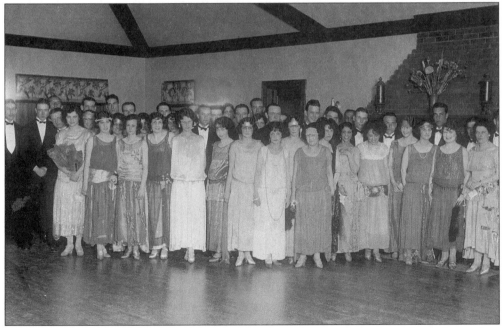

It was not until 1920 that Saint Mary's women and Notre Dame men danced together at social soirées. This dance was a reward to the student body for their efforts in raising money for the LeMans Hall building fund. Due to its success, other co-ed dances followed, such as the one pictured above in the Pine Grove Club House.

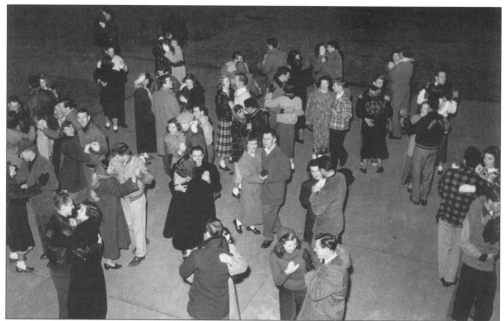

The success of the first mixed dance in 1920 expanded the social experiences of both campuses. Prior to that event, girls danced with girls, and only brothers and cousins from Notre Dame could visit. Sister Claudia's fulfillment of her duties as Prefect of Discipline encouraged strict adherence to the College's codes of conduct.

Dympna Balbach, class of 1916, documented many of Saint Mary's traditions, ceremonies, and pastimes through her hobby of photography. Her photographs serve as windows to a Saint Mary's that we would otherwise never see. Dympna was dedicated to Saint Mary's long after she graduated as evidenced by her attendance at every alumnae reunion until her death and the donations of her scrapbook collection and $1 million to the college.

Because of the distances from their homes and the limitations on receiving outside visitors, the girls relied not only upon their classmates, but also the sisters within the Saint Mary's community to provide their friendships. Perhaps this was the reason for their strong devotion to their Alma Mater and the involvement and cohesiveness of the alumnae.

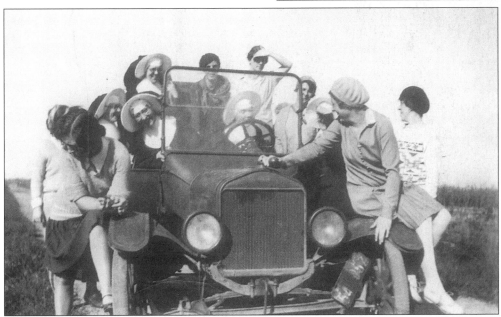

Sisters, students, and alumnae formed the community at Saint Mary's in the past more so than today. At one time, classmates and friends would likely have joined the convent after graduation. The sisters that were part of the faculty were also a crucial part of the girls' lives while at Saint Mary's.

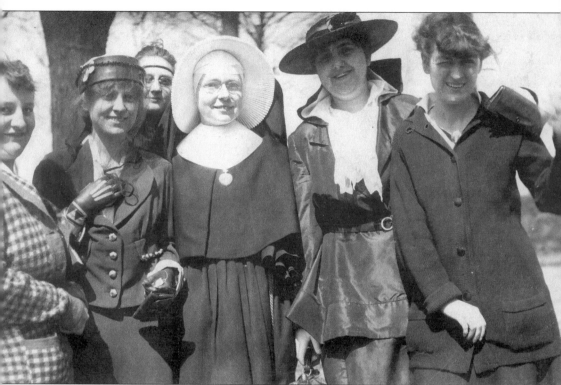

The Association of Post-Graduates of Saint Mary's Academy, Notre Dame, held its first meeting with seven members present in 1879. It is the oldest Catholic women's college alumnae association. The first official reunion was held in 1897, with an elaborate banquet. At this meeting, the purpose of the association was laid down in its constitution, "To preserve the bond of affection between our Alma Mater and her children." The mass that followed its second meeting in 1883 began the tradition of the Reunion Mass. Typically, the Saint Mary's annual alumnae meetings were held in October. Their visits during the fall allowed them the opportunity to visit with both past and current students. Since many girls attended Saint Mary's for several years, they formed friendships with girls in classes above and below them. Later, reunions were held during the summer months, with special attention given to anniversary years.

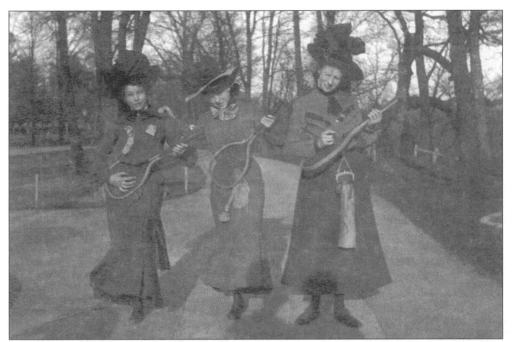

There have always been plenty of diversions and activities for students to share with friends during the recreational periods on campus. Here, students at the turn of the century, identified as Ruth, Viola, and Louise, enjoy each other's company out-of-doors and find alternative uses for their tennis rackets.

The Saint Mary's College Avenue was a rutted lane until the 1922–23 school year when it was first paved. Sidewalks were not added until 1931, much to the chagrin of pedestrians, who strolled underneath its trees during recreation periods. During the 1920s and 1930s, a South Bend streetcar had a stop at the entrance of the Avenue to transport students into town for shopping and treats.

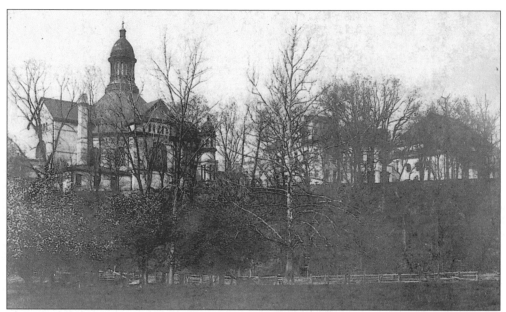

On the lowlands of the Congregation property, along the banks of the St. Joseph River, lays Pearley's Glen. The land was used as a pasture, orchard, and favorite picnic ground. This scrapbook picture gives us a rare view of the first Church of Loretto, the Infirmary, and Saint Angela's Hall.

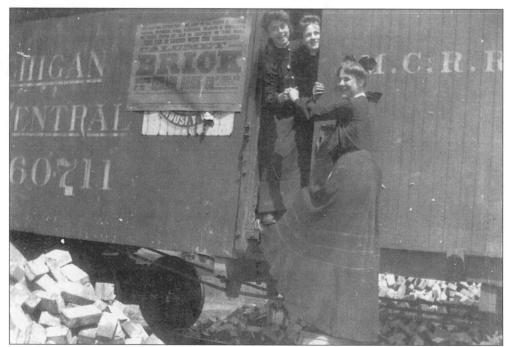

Students, strolling the different areas on campus during their free outdoor time, would explore the oddities they found. In this turn-of-the-century picture, students seem to have happened upon a train car loaded with Calumet bricks manufactured by the *Chicago Brick Co.* These bricks were more than likely used in the construction of Collegiate Hall.

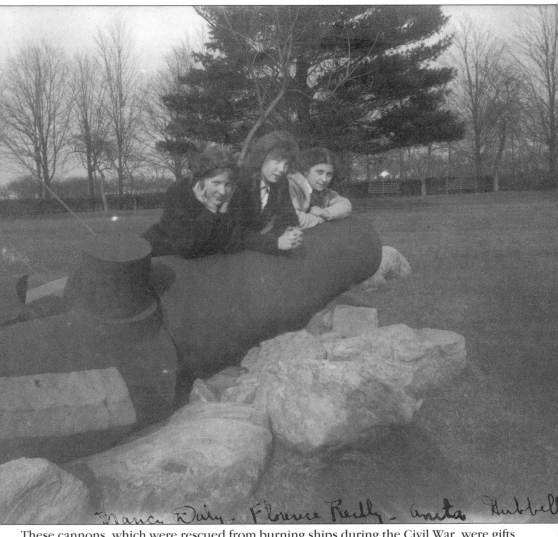

Nancy Daly - Florence Reilly - anita Hubbell

These cannons, which were rescued from burning ships during the Civil War, were gifts to the Sisters of the Holy Cross for their valiant service. Eleanor C. Donnelly wrote, "Cannon in the Convent Grounds," in which she draws attention to the irony of the weapons of war in the peaceful setting.

> *O'er the cold metal, now rusted and rimy,*
> *Year after year the green mosses have crept;*
> *silvery sweet, thro' yon tubes dark and grimy*
> *The bells of St. Mary's their echoes have swept.*
> *Come put your ear to these lips black and hoary,*
> *List to this voice, breathing ruin no more;*
> *The harsh tones grow sweet as they tell of the story*
> *Of Mercy's blest part in the pageant of war.*

Most of the scrapbooks from the era in which this photograph was taken contain pictures of students by Lady Polk and Lady Davis. The cannons remained on campus until they were donated for scrap metal during World War II.

113

The Thanksgiving and Christmas holidays at Saint Mary's were filled with festivities. During the 1920s, those remaining on campus for Thanksgiving took part in a dance in which an orchestra from the Bend played popular selections. The junior class had an annual tradition of caroling on the eve before the student body left for Christmas vacation. Seen here in Stapleton Lounge, the juniors are bundled up before they walked through the halls, outdoor paths and up to the chapel. They would rise early the next morning to awaken their classmates with song and lead them to morning mass. Students who stayed on campus for Christmas break had a host of adventures awaiting them. Midnight mass broke the stillness of the night with the beautiful choir in the brilliantly lighted church. Stockings, gifts, long walks, dancing parties, matinees, Victrola concerts in the Assembly Hall, and candy making rounded out the vacation.

The 1922 *Academic Annual*, predecessor to the *Blue Mantel* yearbook, describes the students' state of mind after a semester away from home: "Ninety-six hours till Christmas Vacation,/ Good bye Old St. Mary's, hurrah for the station." The South Bend train station was undoubtedly the scene of many bittersweet farewells and excited reunions.

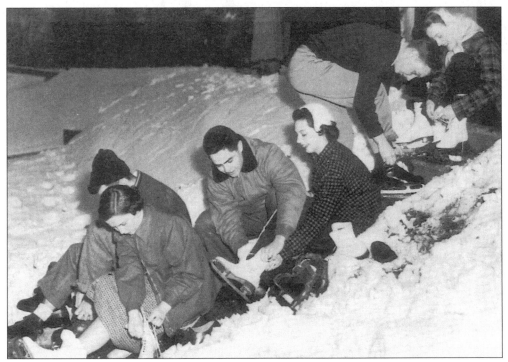

The Winter Carnival, sponsored by the sophomore class, was held annually after the winter break and included ice-skating, dancing, card playing, and a variety show. In this 1953 photo, students of Saint Mary's and Notre Dame lace up for some evening skating on Lake Marian. Later in the 1970s, intramural ice hockey made its appearance.

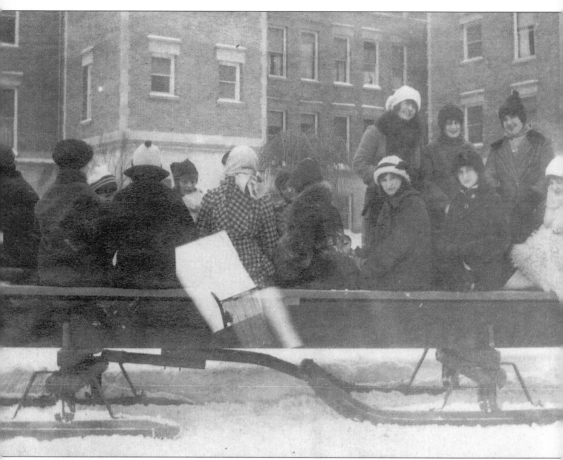

The change of the seasons did not go unnoticed at Saint Mary's, and each one offered its own festivities. Autumn was appreciated for its colors and the anticipation of the upcoming holidays. The ever-present snowstorms of winter that blanketed the campus made studying more enticing, but planning for skating and sleigh ride parties was not neglected.

If it's January, it must be time for the Senior "Bob-ride." "Joy and luck with the Thirds abide/ Today they had a jolly sleigh ride." *(Academic Annual,* 1922). A horse-drawn sleigh pulled the students "togged in true cold-weather school-girl fashion" for a long cross-country ride *(Chimes,* 1912). The day's activities usually culminated in a warm dinner at one of South Bend or Mishawaka's fine hotels. Students looked optimistically on the post-sleigh ride days as the homestretch toward commencement.

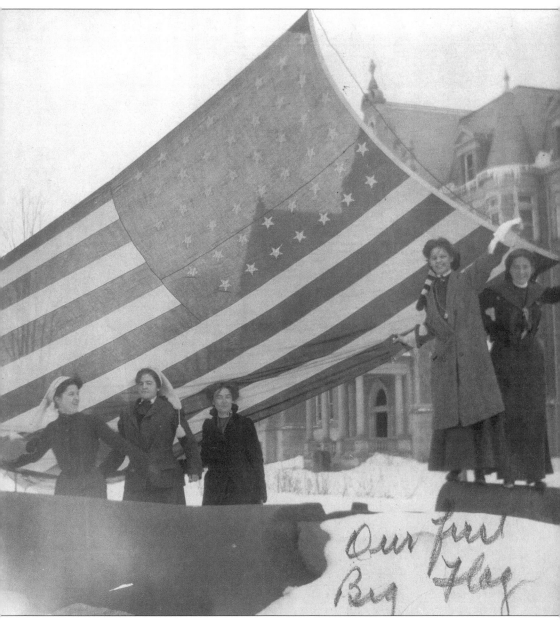

Our first Big Flag

The first part of the 20th century contained many historic world events. During these times there was a need for strong national unity. For these reasons, Saint Mary's welcomed the opportunity to celebrate Washington's Birthday, Memorial Day, Armistice Day, and Flag Day. This picture shows the students proudly displaying the school's first "big flag." Another example of their ardent patriotism was a collection of $1,600, raised during World War I. In addition, the Saint Mary's and Notre Dame College Clubs of Chicago donated an ambulance in the name of the convent. To honor the six priests and 243 Notre Dame students that joined the army, Saint Mary's presented the University with a service flag in 1918. In the fall of that same year, Saint Mary's students spontaneously marched and sang with the flag to the gates of the college when they heard the news that the war had ended.

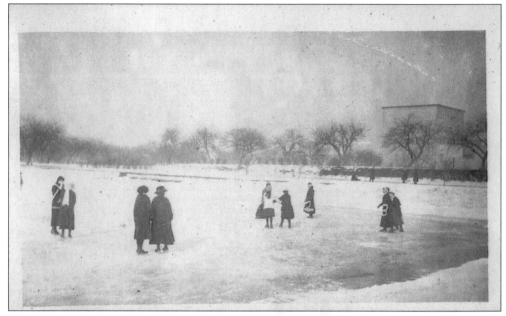

Popular winter sports included tobogganing, snowball fights, and skiing in Wisconsin and Michigan. Lake Marian was an all-season playground; the snow and ice provided many diversions for the women. Frances Lyon, class of 1917, took this photograph of her friends Ella, Louise, and Marie skating on Lake Marian .

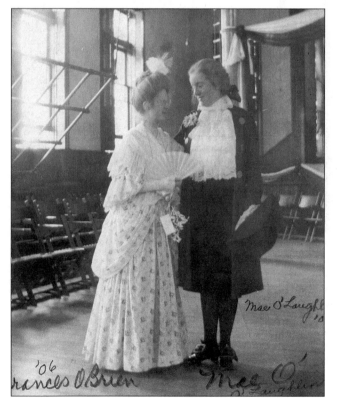

To the contemporary mind, President's Day has little significance; therefore, it is hard to imagine a celebration of our founding fathers with costumes, dancing, patriotic songs, and dainty refreshments. Standing in Saint Angela's Hall, decorated in national colors, Frances O'Brien and Mae O'Laughlin from the class of 1906 are costumed for the occasion.

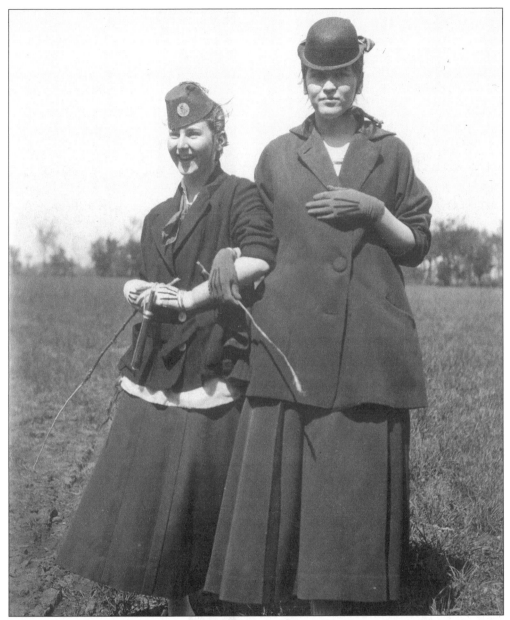

Another significant holiday was Saint Patrick's Day. For many of the women at Saint Mary's, this held both personal and political significance. This selection from the 1912 *Chimes* highlights the personal connection,"Long will the soul of your faith-crested land,/ And the love of your great nation strong,/ Live in your sons on America's strand,/ To stir them in battle and song./ O exiles now loyal to red, white and blue!/ O sons by adoption made free!/ Treasure the old flag, the staff of the new,/ And faithful to both, valiant be" (author listed only as M.M.L.).

Irish home rule was seen as imminent in 1912; little did the author know what conflict lay ahead. At the time this photograph was taken, the fight for Irish independence was underway. Later, Mother Pauline gave Eamon de Valera, the first president of the Irish Republic, "the keys to the city" of Saint Mary's.

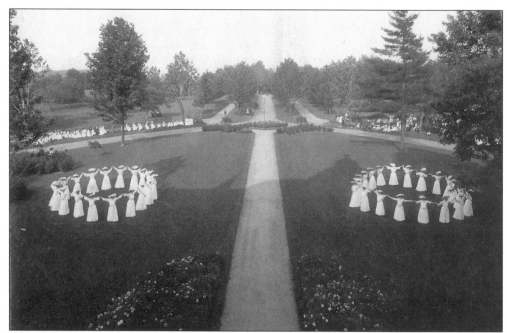

Outdoor celebrations to commemorate religious feast days or special months of the liturgical year were hallmarks of the academic calendar. October and May's openings with the Living Rosary, Founder's Week activities, Christmas caroling, the May Day and May Processions, and Commencement week ceremonies were many of the special functions that gathered the campus together.

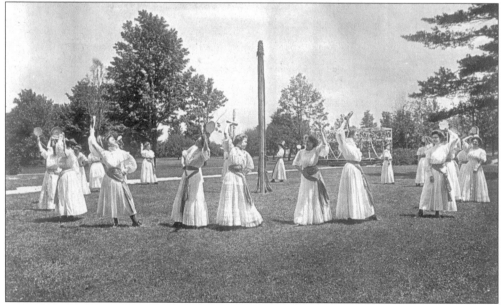

The excitement of May with its warm weather and the return of greening of the grass and trees can be understood by anyone who has experienced a Northern Indiana winter. It is little wonder that the celebration for the month of Our Blessed Mother would have been held out-of-doors and included dancing and singing.

120

In 1911, one of the rare senior privileges was the walk to the "Famous Candy Store." Not only was this a spatial freedom that none of the underclassmen could enjoy, but it was also a freedom from the stringent "eatables" regulations indicated in the college catalog. Students were not allowed "confectionery," because "nothing was more conducive to ill-health than irregularity of the diet."

Long strolls around campus with friends were always a favorite recreational activity. Students wandered throughout the campus delighting in their favorite spots.

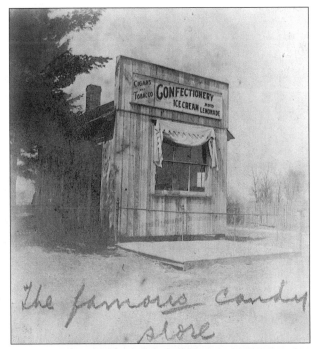

The famous candy store

A certain slant of sunlight,
A whisper 'mong the trees,
Soft, white clouds above me
Tumbled by the breeze,

Bring me memory's pictures,
A tranquil afternoon,
Or a spot I know and cherish,
St. Mary's, sweet in June"

(Excerpt from the poem "Alma Mater" by Maguerite McEnerny).

On Friday, May 18, 1917, Hellen Holland was pulled around in a jaunty-car decorated with red, white, and blue banners in celebration of her being named Valedictorian of the Senior Class. Academics and Collegians alike snapped photographs, cheered, blew horns, rang bells, and sang "The Star Spangled Banner." "Val Day" was a tradition at Saint Mary's for at least 20 years.

Throughout the decades, the end of the academic year has always been filled with exams, the senior class picnic, and Commencement. This week included the cap and gown ceremony, baccalaureate mass, and the graduation exercises. In addition to all the formal closing ceremonies, there was always that most final and frenzied of moments, moving out.

Eight
BEYOND THE AVENUE

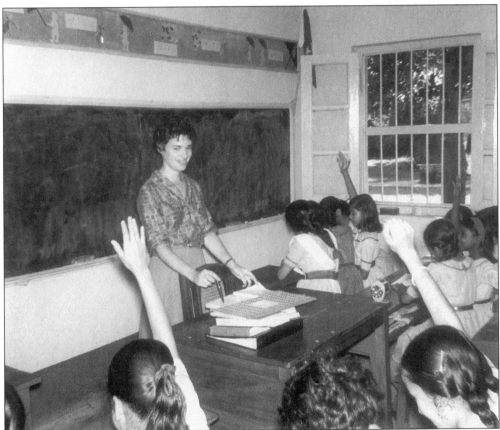

The section entitled "Saint Mary's International" in the 1967 *Blue Mantle* yearbook reported "Saint Mary's is in a position to open doors for study, service, teaching, culture on practically all continents." Students in good standing could arrange a semester or year of foreign study with full credit toward a Bachelor's degree. Lay missionary teaching positions were available through the Sisters of the Holy Cross in Sao Paulo, Brazil, and Dacca, East Pakistan, shown above.

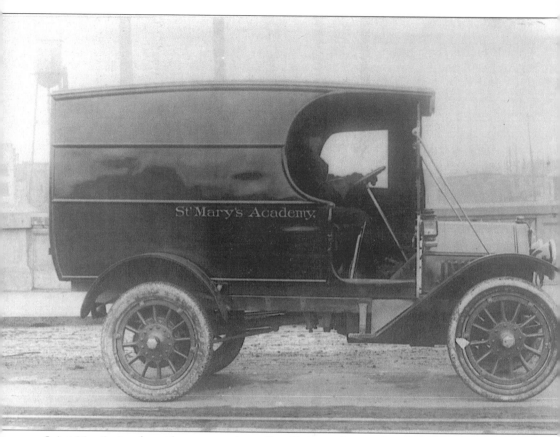

Saint Mary's Academy became quite self-sufficient after its first few decades. The farm supplied it with much of its meat, milk, and grain, and the greenhouse grew some of its fruit. Not everything could be produced within its borders, however, so it was necessary to come into town for supplies, and most importantly, for the mail. Seen here in downtown South Bend is the Academy's mail truck. At the twelve o'clock delivery, every girl anxiously anticipated the announcement of her name. Jessie Foley, class of 1903, observed, "One girl, who appears to be in danger of losing her mental, as well as physical equilibrium, looks as if that expected letter is a matter of life and death!" (*Chimes*, 1901). The college schedule was arranged so that girls would have three hours weekly to write letters home. No letters from outside the immediate family were accepted without pre-approval from the directress and the parents.

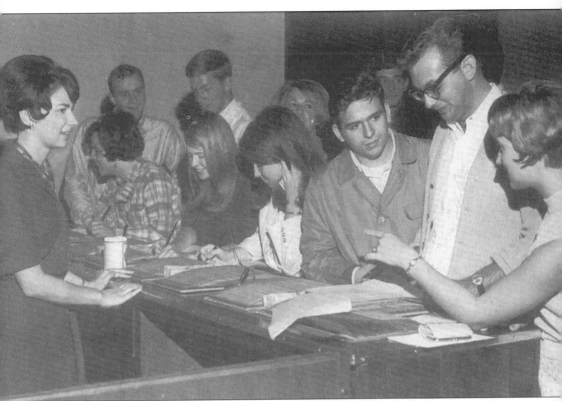

In the early decades of the century, the social lives of the students were highly censored. Even visiting times were regulated. In 1915, students could only receive guests in the parlor from 1:30–4:30 p.m. because, "frequent and protracted visits are highly detrimental to the improvement of the pupils" (*College Catalog*, 1915). Only immediate relatives were received unless visitors presented themselves with a letter of introduction from the student's parents. Prior to the late 1920s, off-campus privileges were never granted to students unless they were with their parents. Later, however, students could apply with the Dean of Freshmen or the Dean of Women to leave campus. Permission was not guaranteed, as the Deans could decide how many times a student could leave per semester, and the number of hours they could be away. In 1962, the six-hour, off-campus limit was abolished. In 1965, the 8:30 p.m. Friday night curfew was eliminated, and seniors were allowed unlimited 10:30 p.m sign-ins.

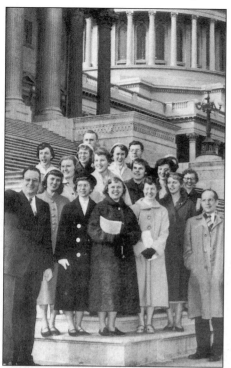

Professor Paul Bartholomew's annual spring trip to Washington, D.C. was a tradition at Saint Mary's in the 1950s and 1960s. Later, as the political events of the 1960s intensified, students from the college secured positions as summer interns in various government offices in Washington. Later, the Political Science Department also arranged internships for students with local government agencies as well.

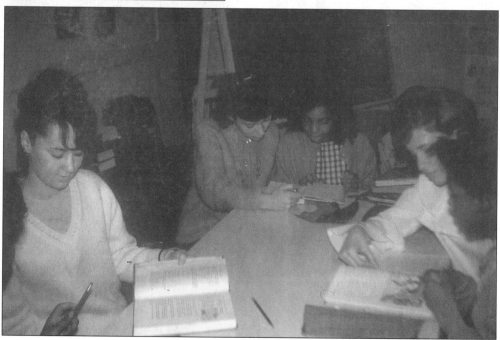

The South Bend Neighborhood Study Help Program began in 1963, with Sister Margaretta organizing a collaborative effort between local colleges, industries, and individuals to tutor children in the South Bend schools. Starting out with only 15 tutors and 15 students, the program grew to 450 children in 19 study centers by 1965, with over 100 Saint Mary's students donating over one hour each week to help.

Informal student and faculty visits to Europe during summer vacations slowly developed, and became more formalized as the Saint Mary's campus spread far beyond the Avenue to several continents. The Rome Program began in 1970, and offered students courses in art, Italian literature, and religious studies, to name only a few. In 1977, the Ireland Program was established in collaboration with St. Patrick's College, Maynooth, Ireland, where Saint Mary's and Notre Dame students joined their Irish counterparts in such classes as literature, history, and sociology. The Semester Around the World Program first explored Japan, Hong Kong, China, Taiwan, Indonesia, Singapore, Malaysia, Vietnam, Thailand, Nepal, India, and Russia in 1983. This semester-long program combines travel with academics at Sacred Heart College in Cochin, India in alternate years. The most recent addition to the international family at Saint Mary's was made in 1999 with the Seville Program. Spanish majors have an opportunity to study language, literature, and culture in Spain. Through this undated and unidentified photograph, one can see how the study abroad programs can change one's perspective on the world.

After leaving Saint Mary's, alumnae expressed their gratitude to their Alma Mater in a variety of ways. Fundraising efforts by alumnae clubs throughout the country have contributed greatly to the college. The first such fund raiser in 1882 resulted in a gift of the south window in the Church of Loretto. To celebrate the Golden Jubilee, the association gave a $4,000 Kimbal organ to the Church of Loretto. Buildings around campus bear the names of many of the most active and generous members. More numerous, yet un-trumpeted, are the hundreds of scholarships that have given so many students the opportunity to benefit from a Saint Mary's experience, and the legacies of great-grandmother, grandmother, mother, and daughter sharing a Saint Mary's tradition. The essence of Saint Mary's that graduates carry with them as they venture beyond the avenue is as visible as the rings they proudly wear on their fingers. Like the rings themselves, there is an unbroken circle of memory and action that brings them, and others, to the Avenue.

BIBLIOGRAPHY

Creek, Helen (Sister Mary Immaculate, C.S.C.). *A Panorama: 1844–1977 Saint Mary's College, Notre Dame, Indiana*, Notre Dame, IN: Saint Mary's College, 1977.

McAllister, Anna Shannon. *Flame in the Wilderness: Life and Letters of Mother Angela Gillespie, C.S.C.*, Notre Dame, IN: The Sisters of the Holy Cross, 1944.

McCandless, Marion. *Family Portraits: History of Saint Mary's College, Notre Dame, Indiana*, Notre Dame, IN: Saint Mary's College, 1952.

Wagner, Sister Monica, C.S.C. *Benchmarks: Saint Mary's College How It Grew*, Notre Dame, IN: Saint Mary's College, 1990.